THE DÜNGEONMEISTER GOBLIN QUEST COLORING BOOK

FOLLOW ALONG WITH—AND COLOR—THIS ALL-NEW RPG FANTASY ADVENTURE!

JEF ALDRICH & JON TAYLOR Illustrated by ZACHARY BACUS

Adams Media

New York London Toronto Sydney New Delhi

Adamsmedia

Adams Media
An Imprint of Simon & Schuster, Inc.
100 Technology Center Drive
Stoughton, Massachusetts 02072

First Adams Media trade paperback edition October 2023

For information about special discounts for bulk purchases, please contact Simon & Schuster Special Sales at 1-866-506-1949 or business@simonandschuster.com.

The Simon & Schuster Speakers Bureau can bring authors to your live event. For more information or to book an event, contact the Simon & Schuster Speakers Bureau at 1-866-248-3049 or visit our website at www.simonspeakers.com.

Interior design by Julia Jacintho
Illustrations by Zachary Bacus

Manufactured in the United States of America

10 9 8 7 6 5 4 3 2 1

ISBN 978-1-5072-2120-4

Contents

Introduction

Are you ready for adventure? Then grab your legendary Bag of Coloring Pencils. Get situated in your Throne of Comfort. And let the spirit of creativity and fun overcome you in this epic coloring-book-meets-RPG-campaign!

Within *The Düngeonmeister Goblin Quest Coloring Book*, you will find larger-than-life heroes who need your help to bring a little color to their brave deeds. Come along on their interactive journey as they go from the local town to a goblin warren, and deep into the lair of their true enemy. Marvel at, and color in, the unique treasures and magical equipment that come from the life of dungeon delving. By rolling the dice, decide which potions your adventurers collect or what type of foe they face. Use what happens on these pages and through your dice rolls to inspire your own campaign! Thrill at the many monsters and magical misanthropes that attempt to stymie our daring do-gooders at every turn—no game master (GM) required.

Within each arc of the story, from meeting the party to facing the final boss, you'll be along for the ride in a fantasy adventure full of interesting locations and engaging characters. Not only will you get pages and pages of beautiful illustrations just waiting for your artistic flair; you will also get maps that detail the areas the courageous party will be traveling within and tables of random encounters that move you right into the dice-throwing action. Use your d10 and d12 to influence how you color some of the pages or what action happens between the scenes! Not only are you getting a coloring book, but also the tools to run an adventure of your own through the lands detailed within.

Whether you're looking to color in the engaging story, determine what action happens to the heroes behind the scenes, or find inspiration for your real-world campaign, this coloring book has something for you! So put away your swords, prepare your creative cantrips for the day, and get ready to color your way through this fun-fueled, adventure-packed quest!

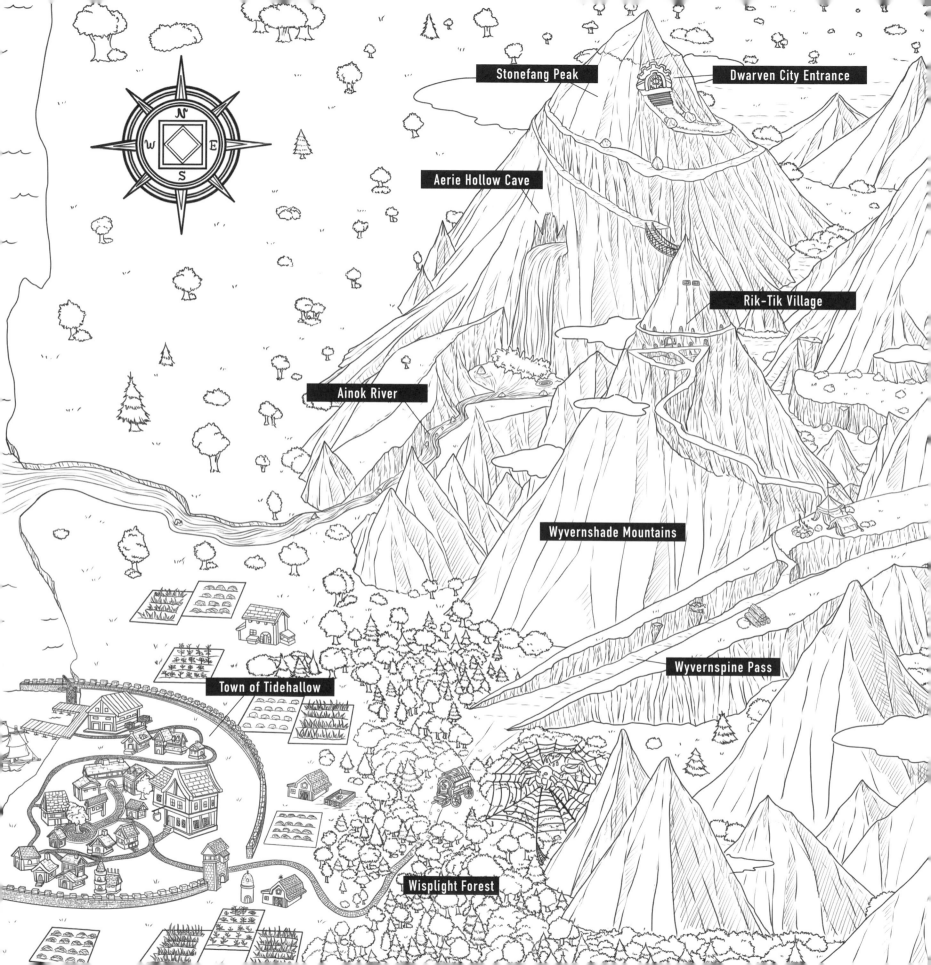

Meeting the Party:
Greenscale Company Is Called Upon

A blanket of storm clouds smothers the sky over the sleepy dockside town of Tide-hallow. Villagers and visiting fisherman alike huddle in firelit taverns, and the streets are empty save for rivulets of mud from an afternoon downpour draining away toward the choppy sea. Under the cover of the darkened sky, a band of mischievous goblins begins their raid of the dockside warehouses. Led by an expertly trained goblin ranger, Gryll, and her drooling and cackling dire hyena, Riot, the goblins fill their grime-caked rucksacks with dried fish, sailing tackle, and the spoils of local farmland bound for export to faraway cities.

As the fearsome warband loads their ill-gotten spoils into their packs, our heroes, safe and unaware, spend the last of their recently acquired gold and silver pieces in the rousing company of farmers and fishermen at the Pig & Whistle Tavern. Our party, the Greenscale Company, is a hearty and daring band of heroes and adventurers, consisting of the stalwart dragonborn battle captain, Ahmon Greenscale; the sly and accomplished halfling rogue, Catalina Aislinne; the solemn and steadfast human paladin, Lassiter Aurum; and the comical, self-absorbed tiefling warlock, Jack Stonebridge. When morning breaks over the far horizon of the sea, our heroes learn of the goblins' trickery, and the Greenscale Company investigates the warehouse. Will this unlikely group answer the call to quest once more, and chase the wicked goblin thieves into the foothills of the Wyvernshade Mountains? And what further adventures and peril await on the journey ahead?

Tidehallow Encounter

Roll a d10 to determine what your party encounters while preparing to leave the dockside warehouse before the start of their journey.

Roll	Encounters
1	A group of belligerent drunks; ends on friendly terms
2	A group of belligerent drunks; fight breaks out
3	City watch chasing a cutpurse
4	Cutpurse attempting to steal from your party
5	Roving pirates out for trouble
6	Ruffians attempting to mug an innocent citizen
7	Town crier telling the news of the day
8	Skulking goblin in an alley with a sack of goods on their back
9	Street preacher extolling the virtue/wrath of the local sea goddess
10	Wandering minstrels performing a song that is just awful

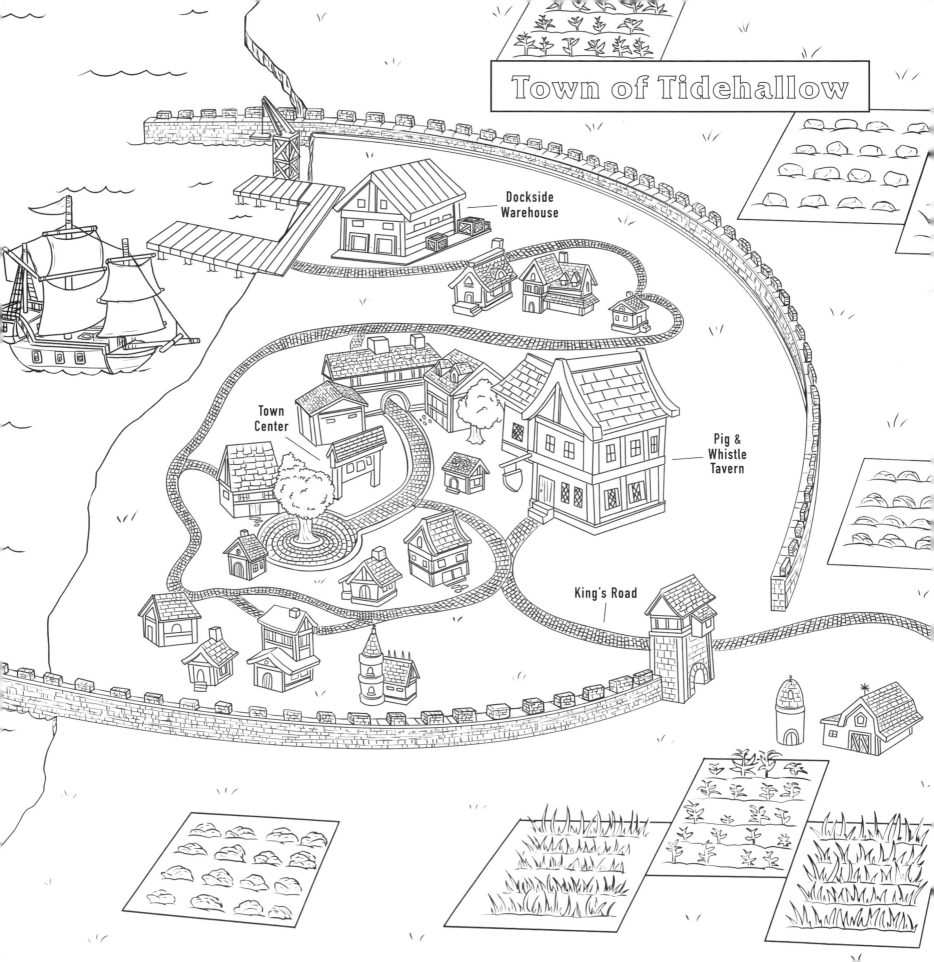

Town of Tidehallow

Dockside Warehouse

Town Center

Pig & Whistle Tavern

King's Road

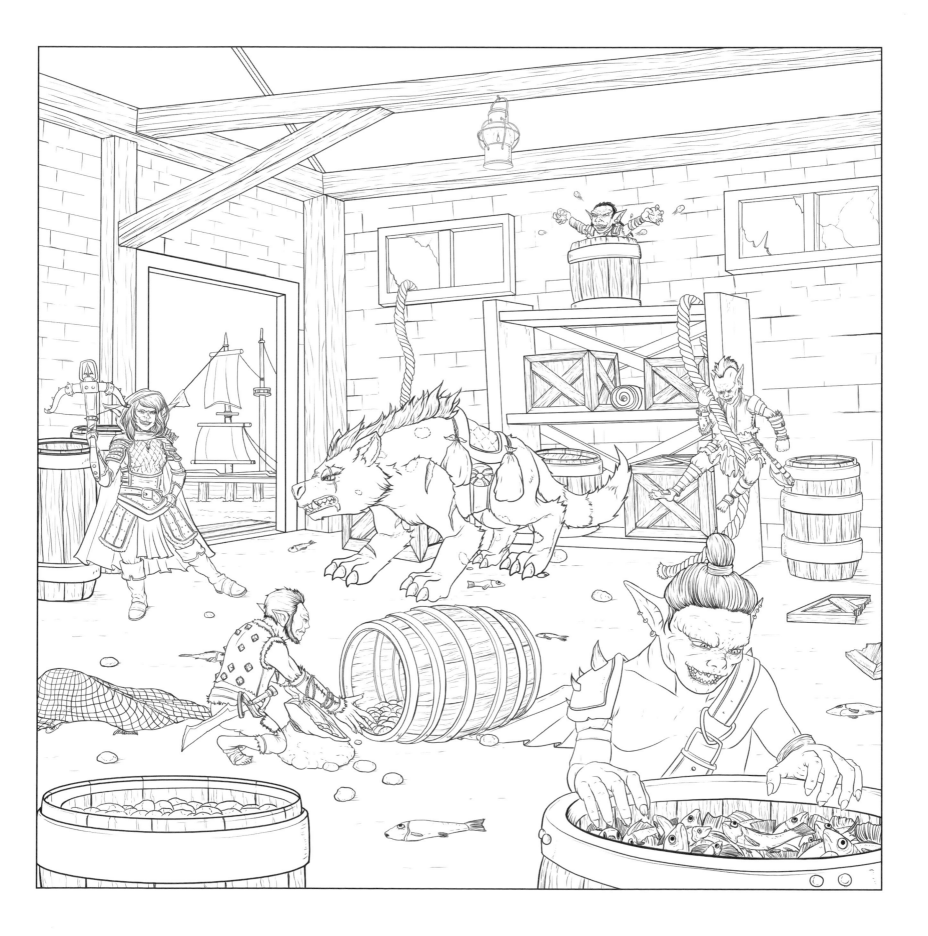

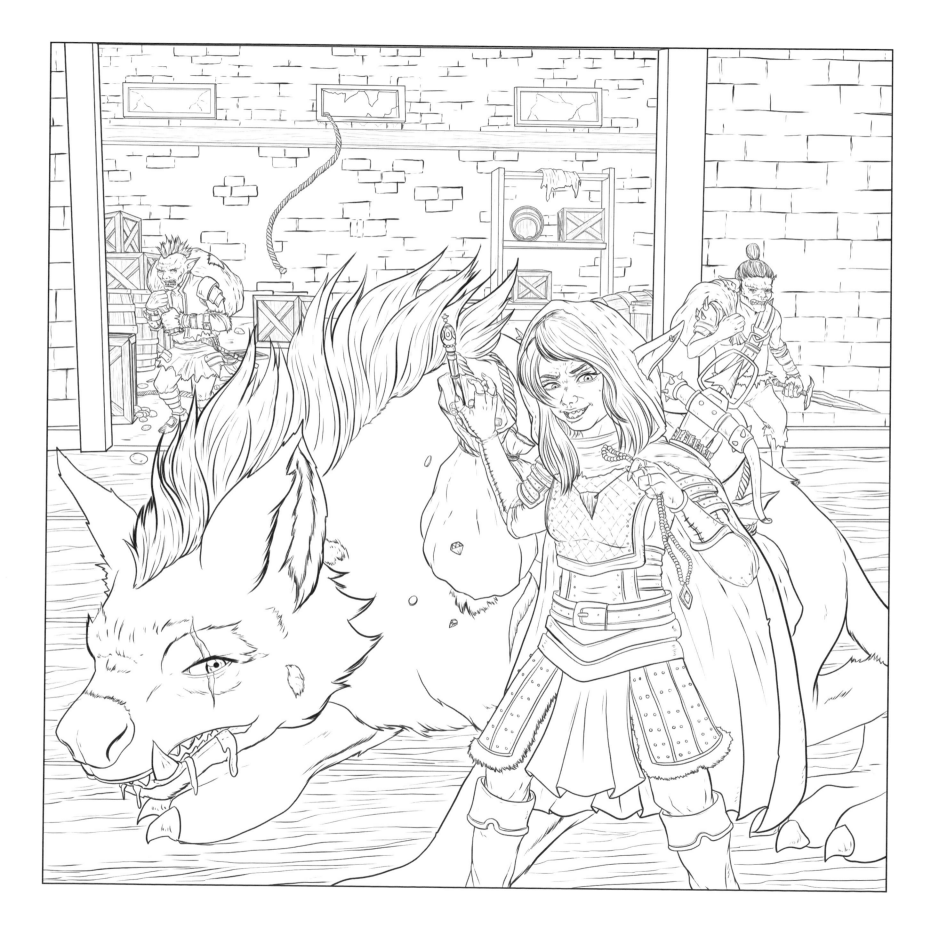

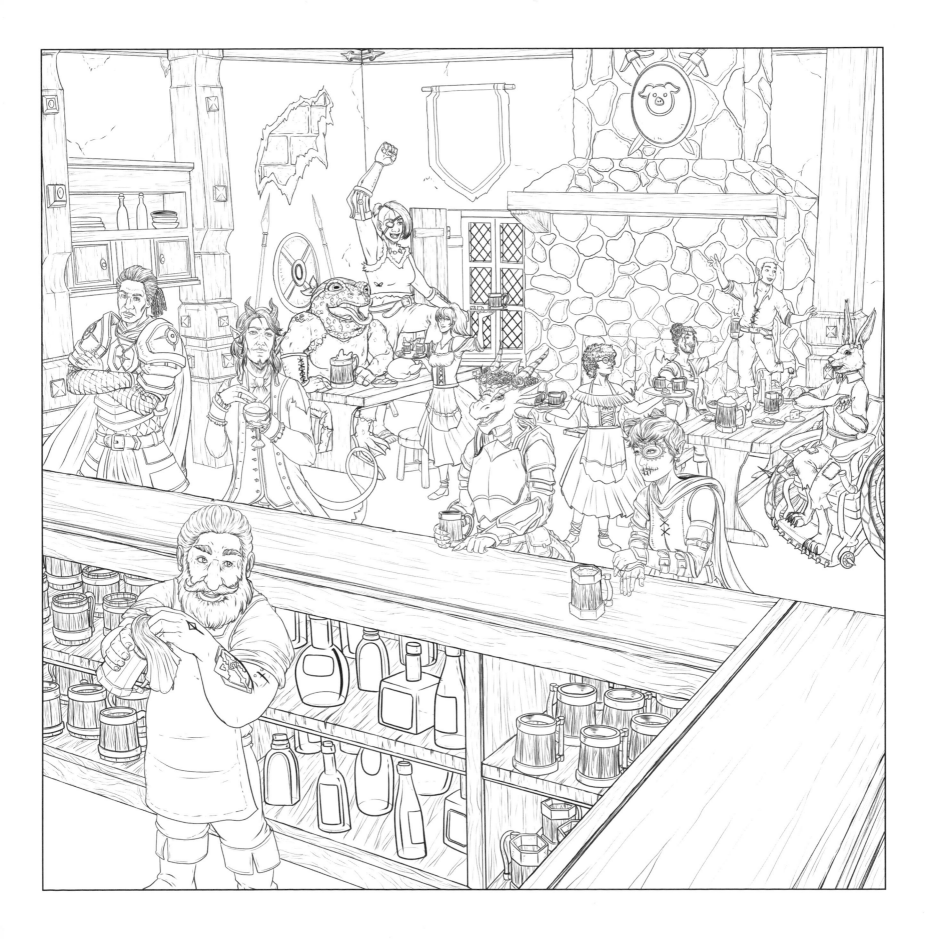

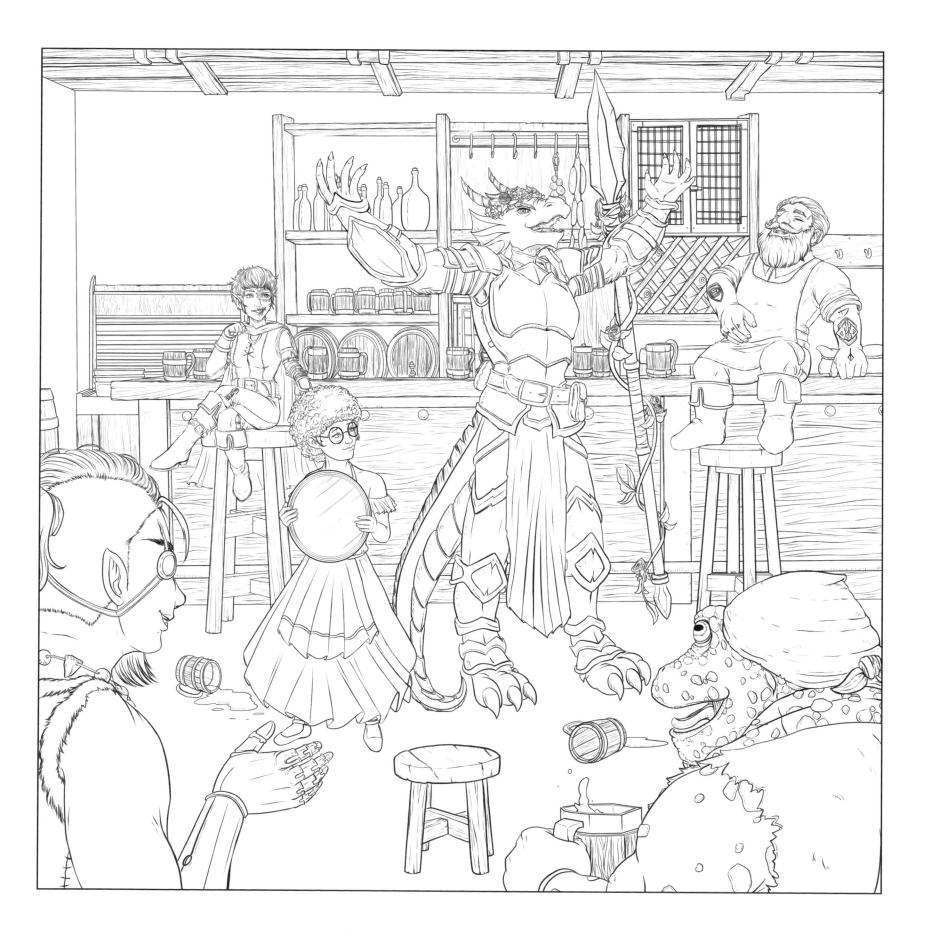

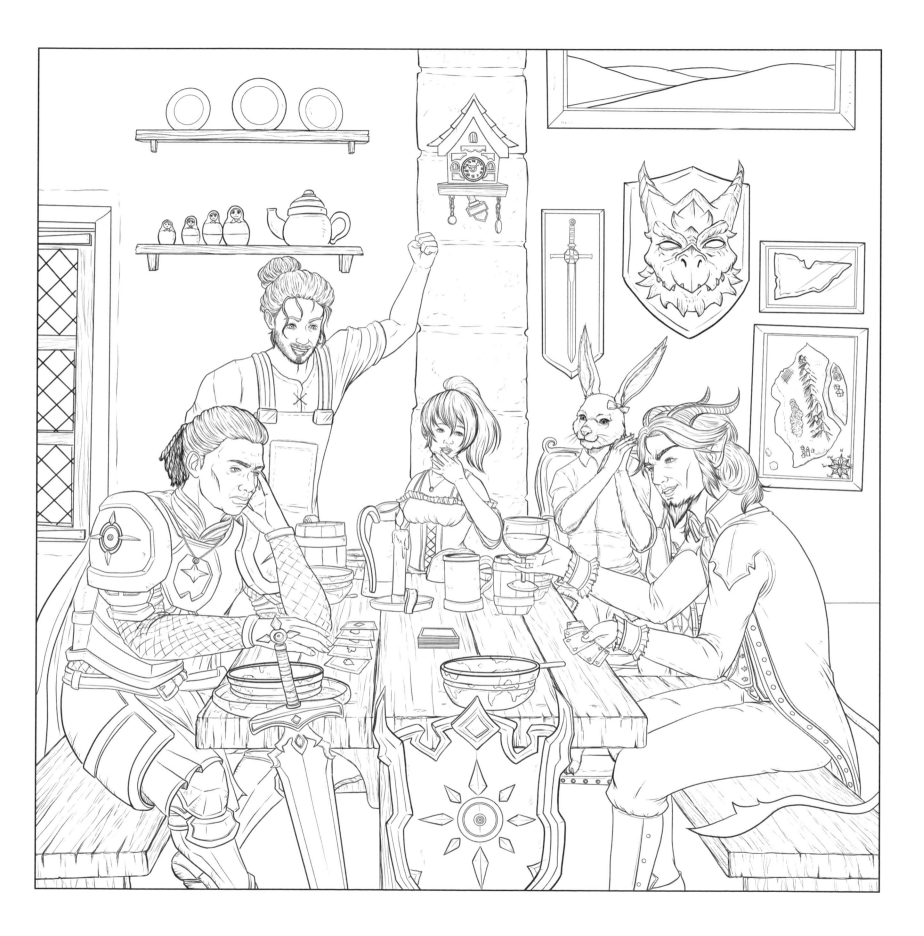

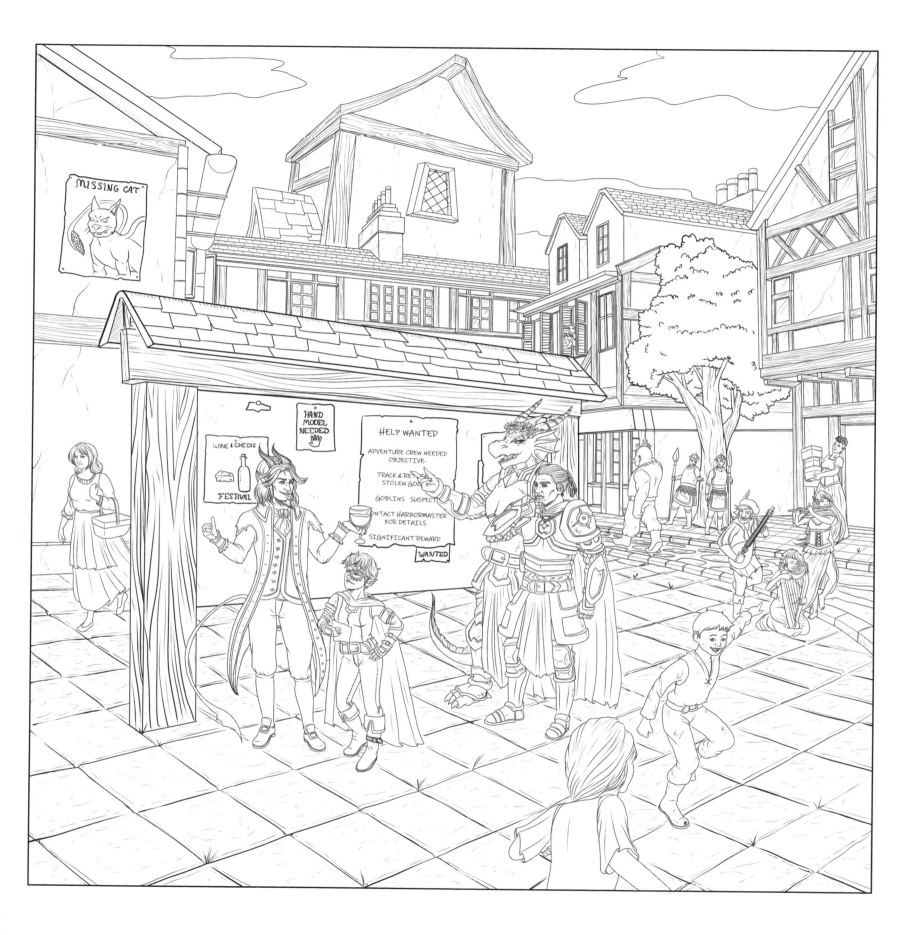

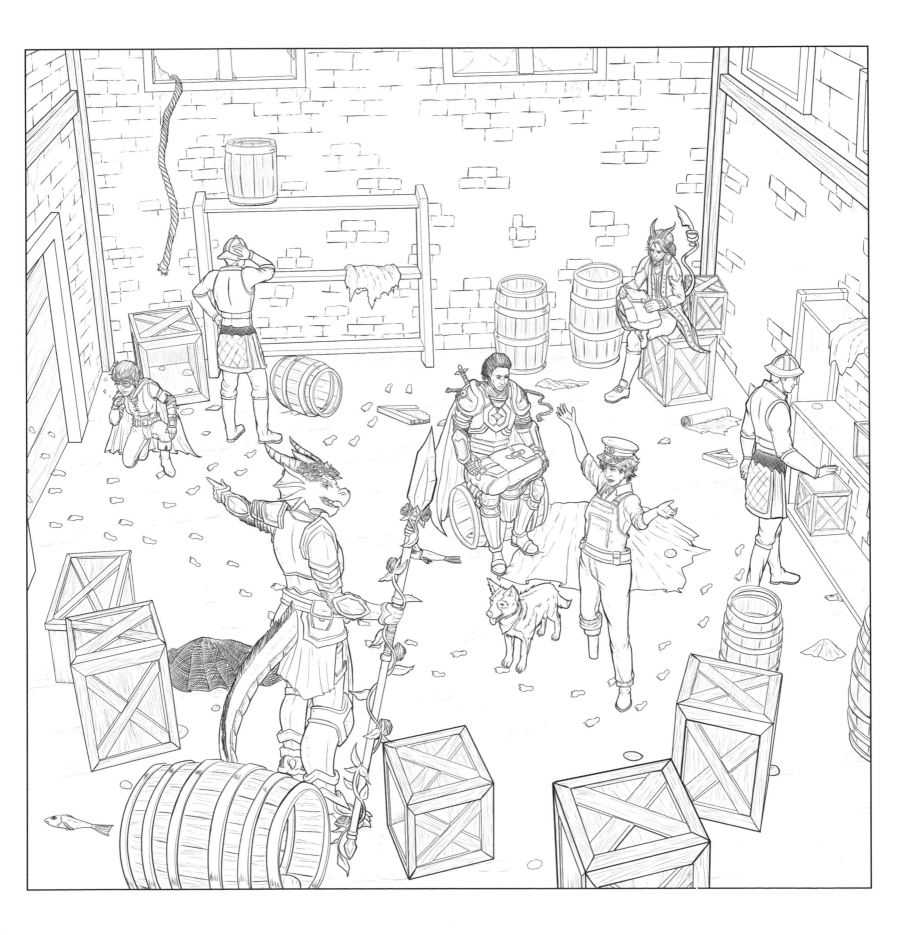

The First Encounter: Entering the Wisplight Forest

After reviewing the aftermath of the goblins' raid in the dockside warehouse, the adventurous heroes set out on their journey in high spirits. The goblin warband, led by Gryll and Riot, has escaped into the murky and vast Wisplight Forest, but the Greenscale Company pursues their enemies quickly, determined to stop them. Though the dense tangle of trees and vines around the path impedes our stalwart heroes, not long into their journey, they hear the sounds of combat ring out among the autumn leaves.

In front of a large wooden merchant-style cart, the group sees a traveling salesperson and his unexpected companion, a talented and solemn goblin cleric named Grobtic. This duo is defending themselves from the very group of goblins the heroes are looking for! With the help of the skillful adventurers, the warband is quickly and soundly defeated. The grateful merchant offers potable rewards and agrees to return the goblins' stolen goods to Tidehallow as thanks. Grobtic, clearly troubled, explains that most of his kin are acting in desperation and he has been exiled from his clan. Deep in the Wyvernshade Mountains, he explains, a malevolent presence has been forcing the goblins into service.

After the party expertly slays some malicious spiders, they exit the forest and steadily ascend the mountains, trying to find the source of the goblins' evil deeds.

Traveling Salesperson's Potion Reward

Use this table in one of two ways to determine the heroes' rewards. First, using a d12, roll once for each party member and color the illustration page to showcase each potion based on this table. Or you can color as you'd like, then match the colors to their table entries to see the potion's effects.

Roll	Color	Potion Appearance & Effect
1	Red	Lava in a glass vial; permanent illusory fire over stopper. Imbiber gains immunity to fire for ten minutes. During this time, their hair sets aflame and can set flammable objects ablaze.
2	Purple	Boiling fluid in a clear glass vial; cool to the touch. Imbiber becomes intangible and gains a Fly speed equal to their Run speed for one minute. They also turn purple for the duration.
3	Gold	Slimy potion with moving tendrils. Imbiber gains a Climb speed equal to their Run speed for one minute (or their existing Climb speed is doubled) and grows tendrils grabbing nearby objects.
4	Rainbow	Shimmery rainbow fluid in an ornate vial. Imbiber becomes invisible for one minute, unless they attack. Invisibility ends with a loud "POP" like a bursting bubble.
5	Black/ Gray	Vial appears to be full of spiders. Vial is in fact full of spiders. Will deal 1d10 + 5 poison damage in a 5' area if thrown. The spiders may be released for 1 "spider favor."
6	Brown	Wooden horn full of fluid; corked with a mushroom. Imbiber passes through non-intelligent vegetation with no resistance and may speak to vegetation (it remembers up to two hours).
7	Green	Syringe full of glowing green ooze, turtle-like in color. Recipient gains a +4 AC bonus and advantage for one minute on any attacks made with swords, daggers, flails, and quarterstaffs.
8	Silver	Vial contains a cloud of silvery gas. Imbiber gains advantage on persuasion rolls for two minutes, and suffers disadvantages on disguise checks due to a literal silver tongue.
9	Orange	Vial is full of a pulpy sweet fluid. Imbiber gains advantage to saves against poison and disease for a twenty-four-hour period and feels ready to start their day with a healthy, balanced breakfast.
10	Uncolored	Fluid inside an unbroken geode—must be cracked to drink. Imbiber shapes stone as easily as clay for five minutes and is cursed to explain rock types to anyone they see during this time.
11	Patterned	Potion is in an opaque vial with a tag indicating it's from "Grandmother." Vial contains five silver and a new scarf. The scarf is enchanted, but only slightly (it doesn't ever get dirty).
12	Blue	Vial marked "Healing Potion." Contains a regular healing potion (1d8 + 1 HP recovered). Flavor is sour raspberry. Calories: 5.

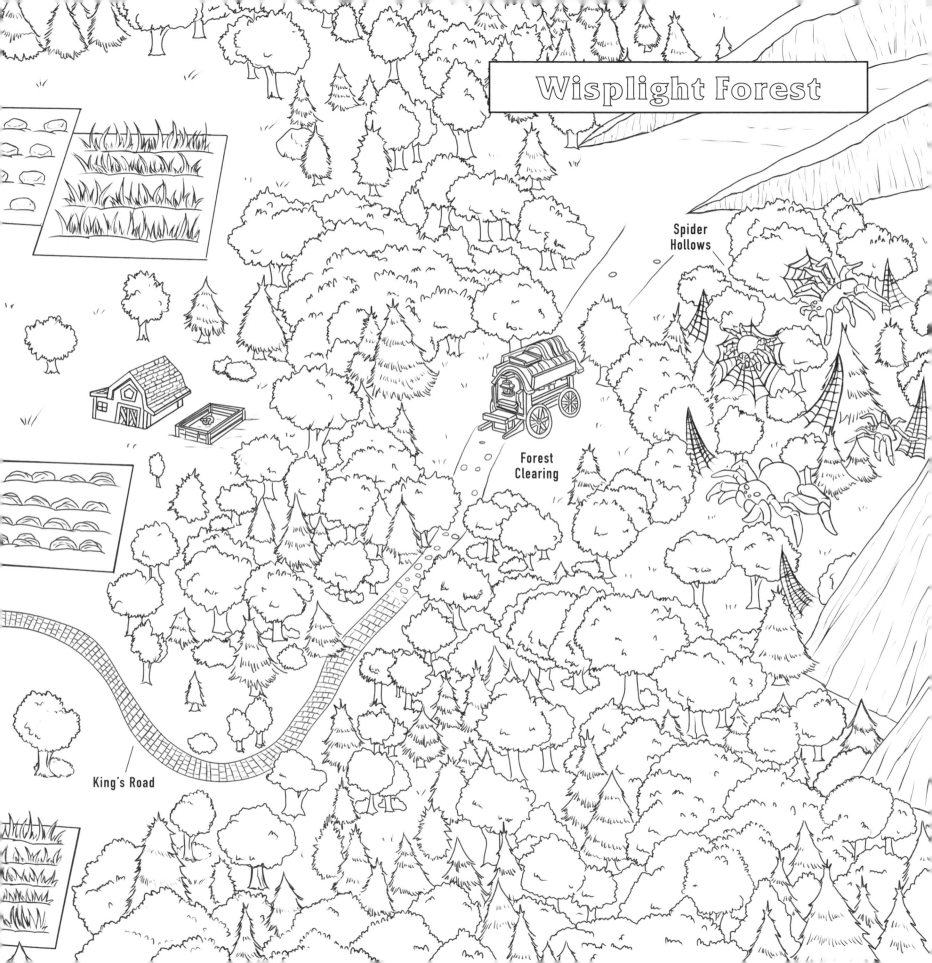

Wisplight Forest

Spider Hollows

Forest Clearing

King's Road

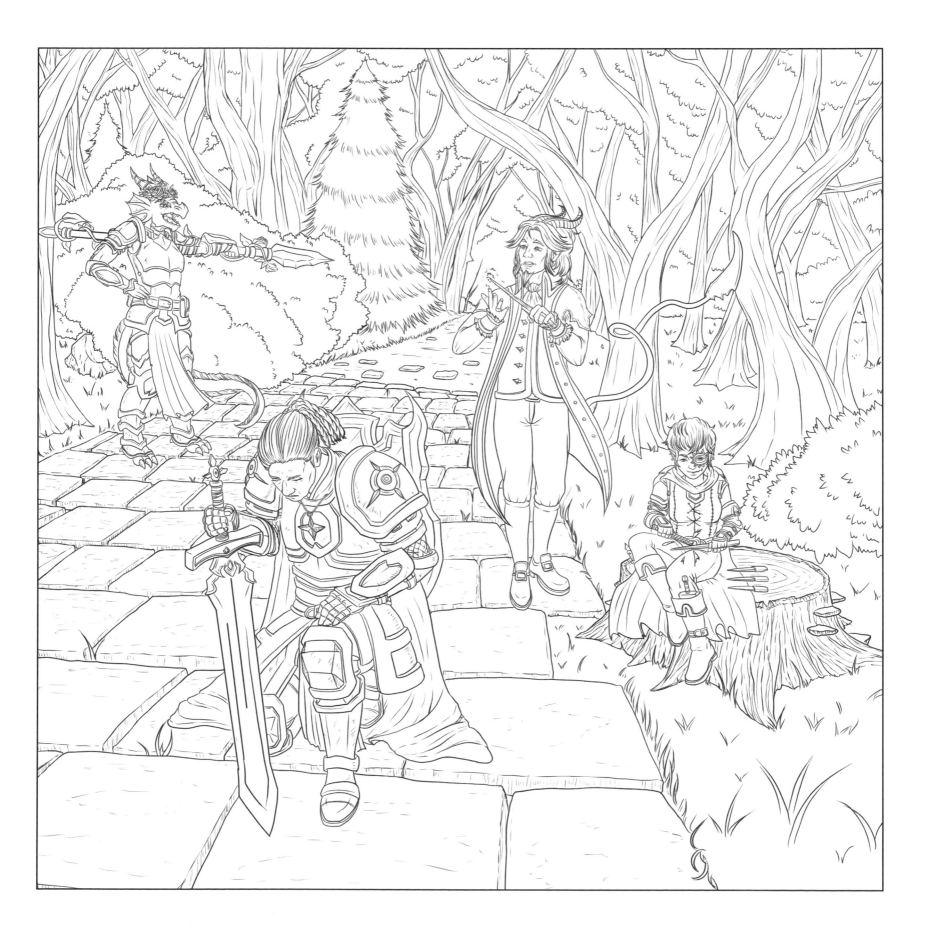

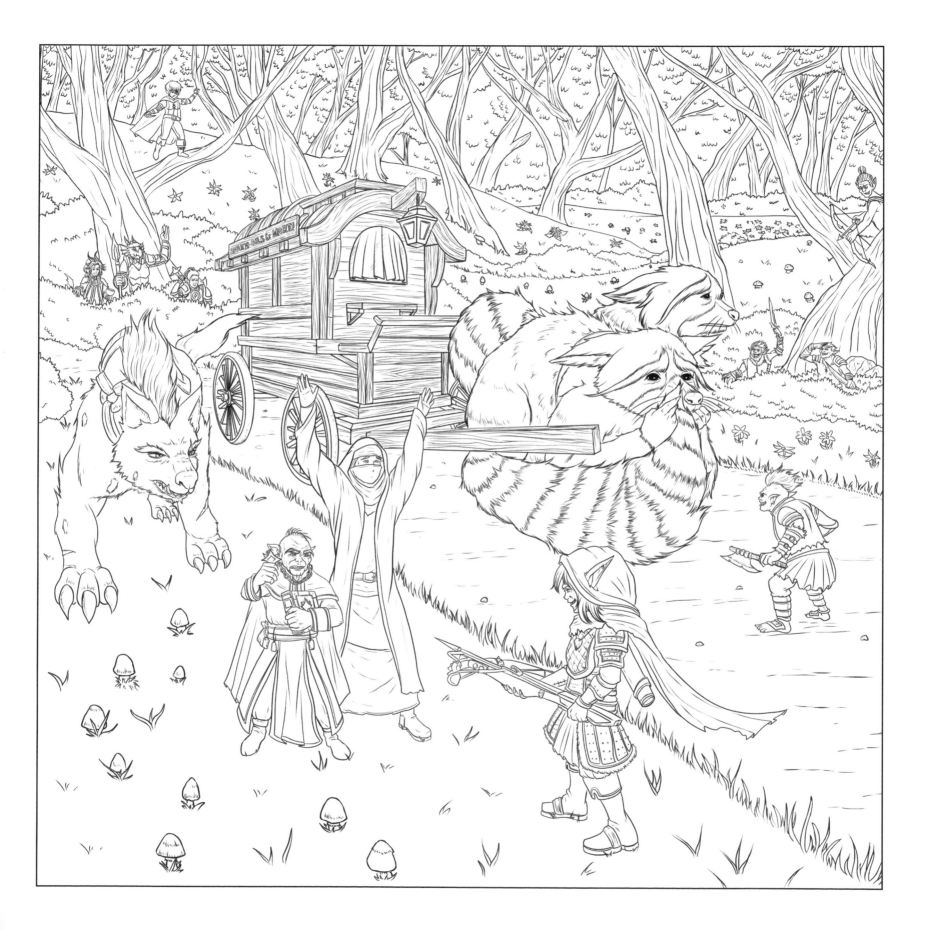

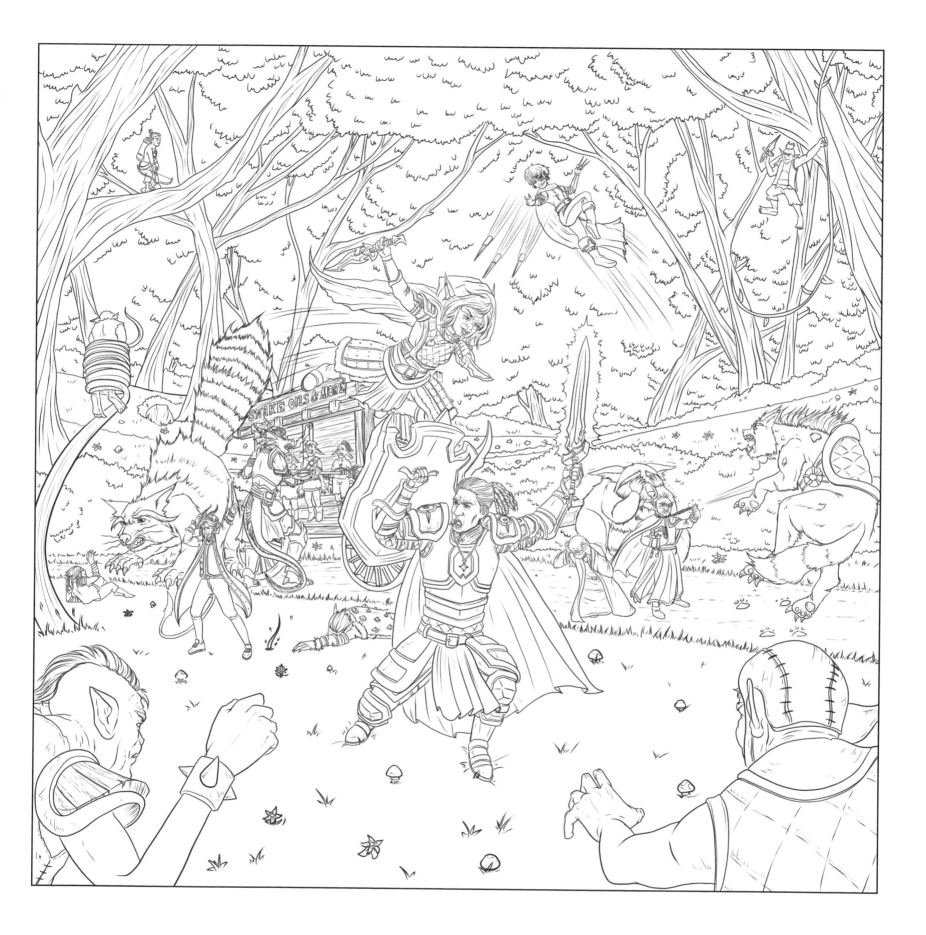

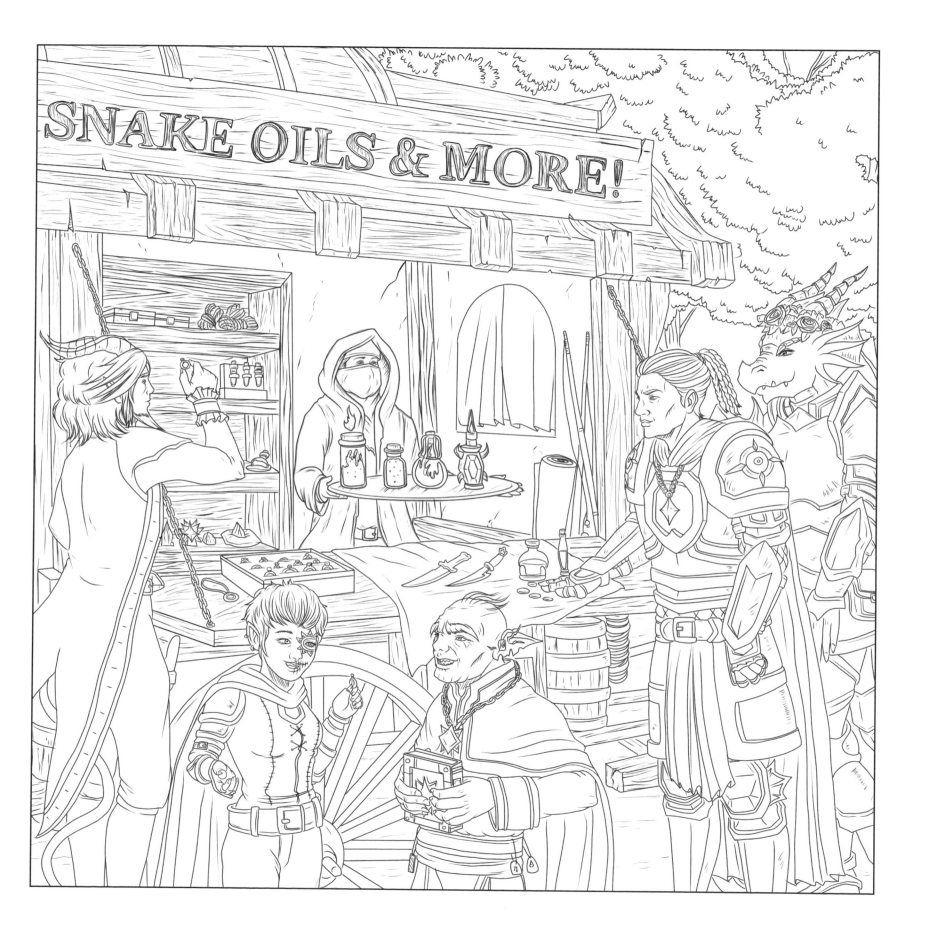

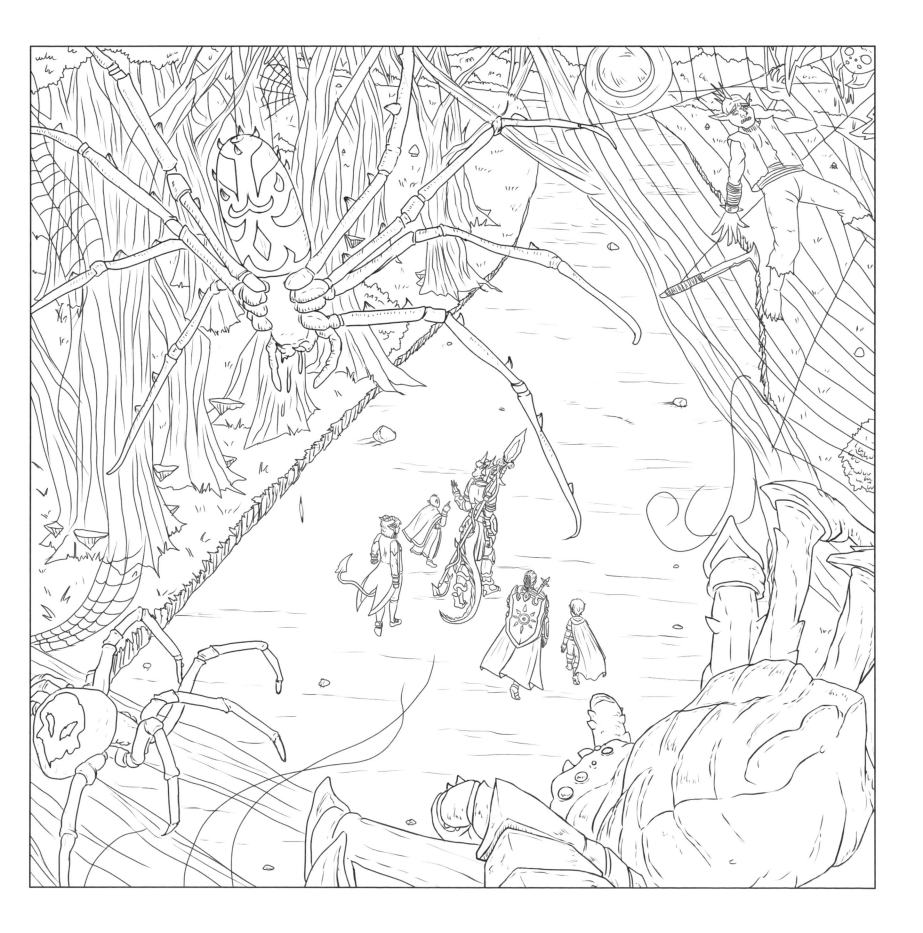

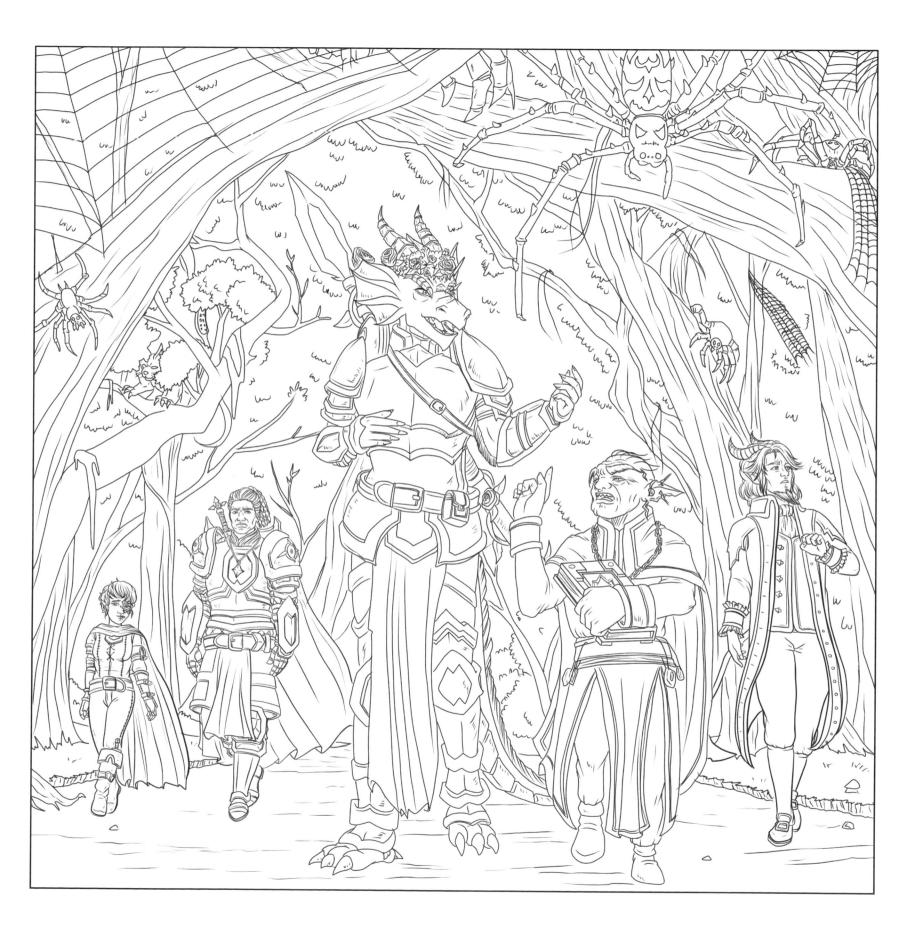

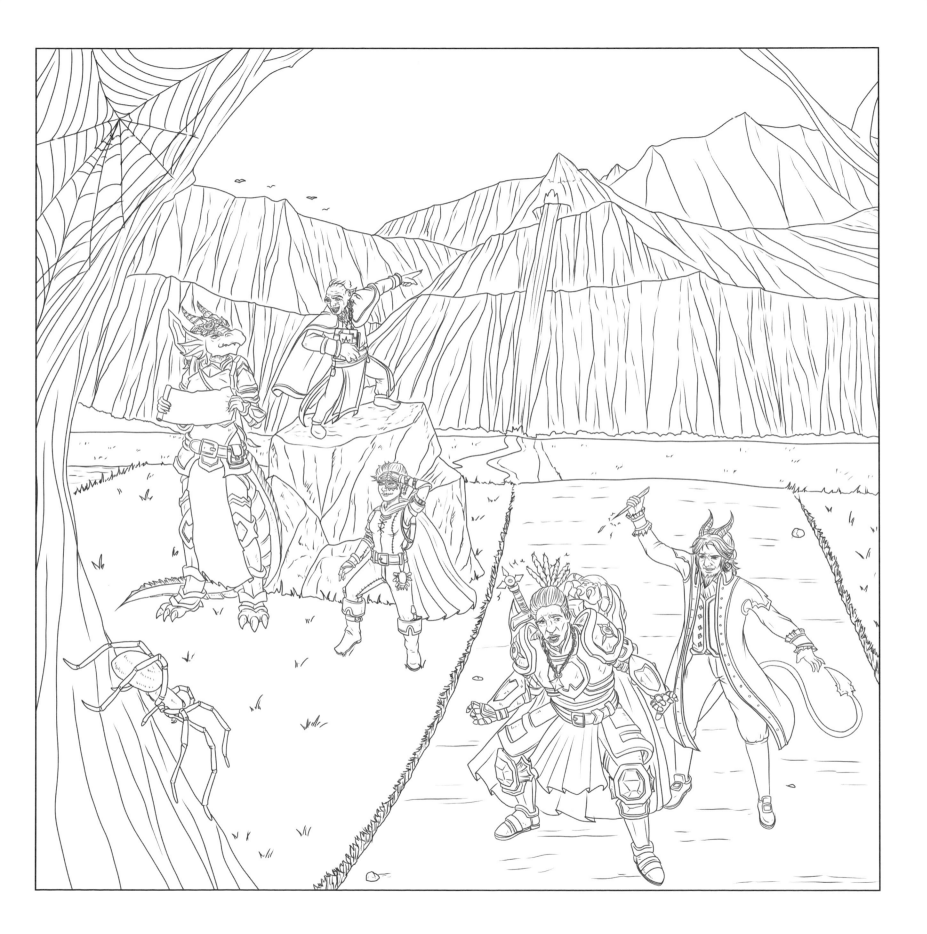

The Plot Thickens: Escaping the Goblin Lands

Traveling through the woods is relatively easy after the initial encounter with the goblins, if a little spooky due to the large spiders. The Greenscale Company makes it to the end of the forest into increasingly rocky terrain. Eventually, following the King's Road, the group pushes through to the foothills of the Wyvernshade Mountains.

As the heroes carefully navigate through Wyvernspine Pass, an ambush awaits them from the steep cliff walls. A rockslide seemingly comes out of nowhere as two strong and fearsome ogres hurl logs and bushes down from the pass. The heroes scramble for cover amongst the rubble, eventually regaining their footing and narrowly beating their foes.

The hard-won encounter leaves the group weary as night falls, and they decide to hunker down for the evening, taking a well-earned rest. A warm meal and friendly conversation bolster the group's spirits as they ascend higher into the mountains the next day.

With Grobtic as their guide, the heroes find a secret path through the goblin warrens that will hopefully allow them to pass through Rik-Tik Village unharried. They sneak through a small cavern opening and brace against the cliff wall, sneaking past the bustling goblin village.

Wyvernspine Pass Encounter

Instead of this storyline's choice to have two ogres throwing boulders at your party, why not roll a d10 to see what fun awaits your party? (Heads up: You might end up with an ogre ambush on your hands anyway!)

Roll	Encounters
1	A goblin raiding party returning home
2	An avalanche
3	1d6 + 3 damage from harpies that are not happy to see you
4	Two ogres throwing logs from the mountainside
5	A traveling merchant laden with goods
6	Fallen rocks block your path; clear them or find a way around
7	A sasquatch/yeti that just wants to be left alone
8	A pair of cyclopes arguing over the answer to a riddle
9	An ettin wants you to have a drink with them
10	1d8 + 4 damage from poisonous snakes—don't eat them

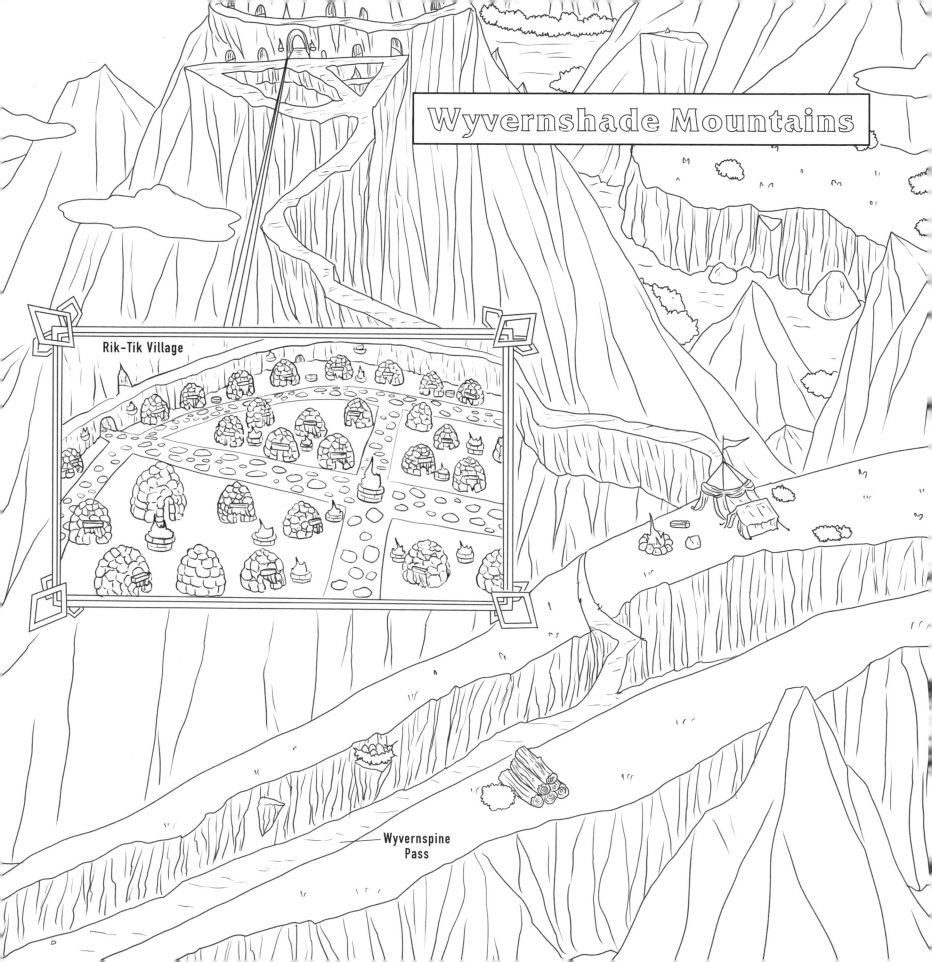

Wyvernshade Mountains

Rik-Tik Village

Wyvernspine
Pass

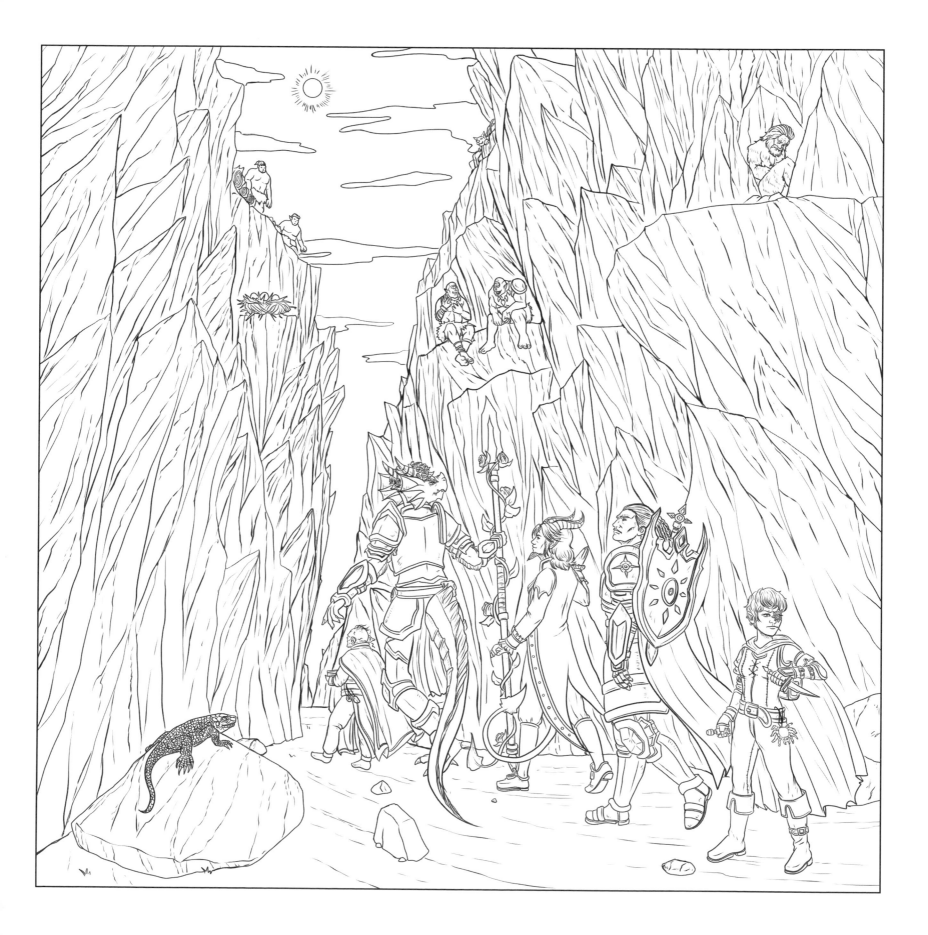

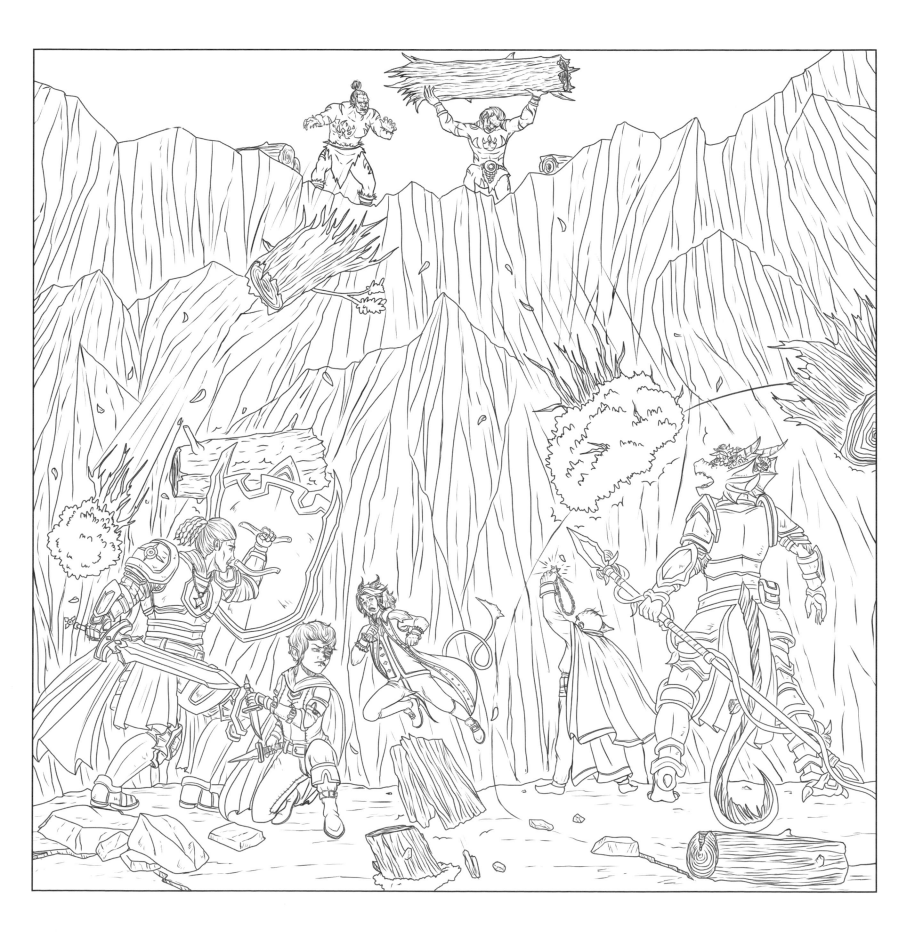

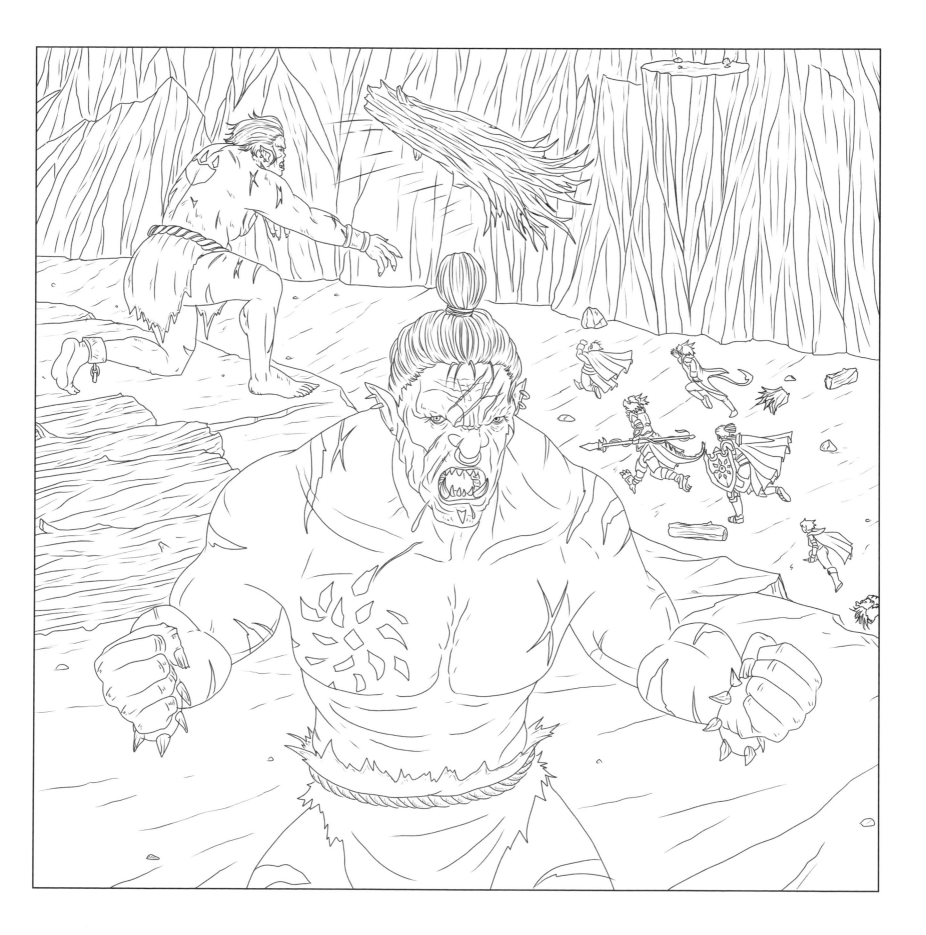

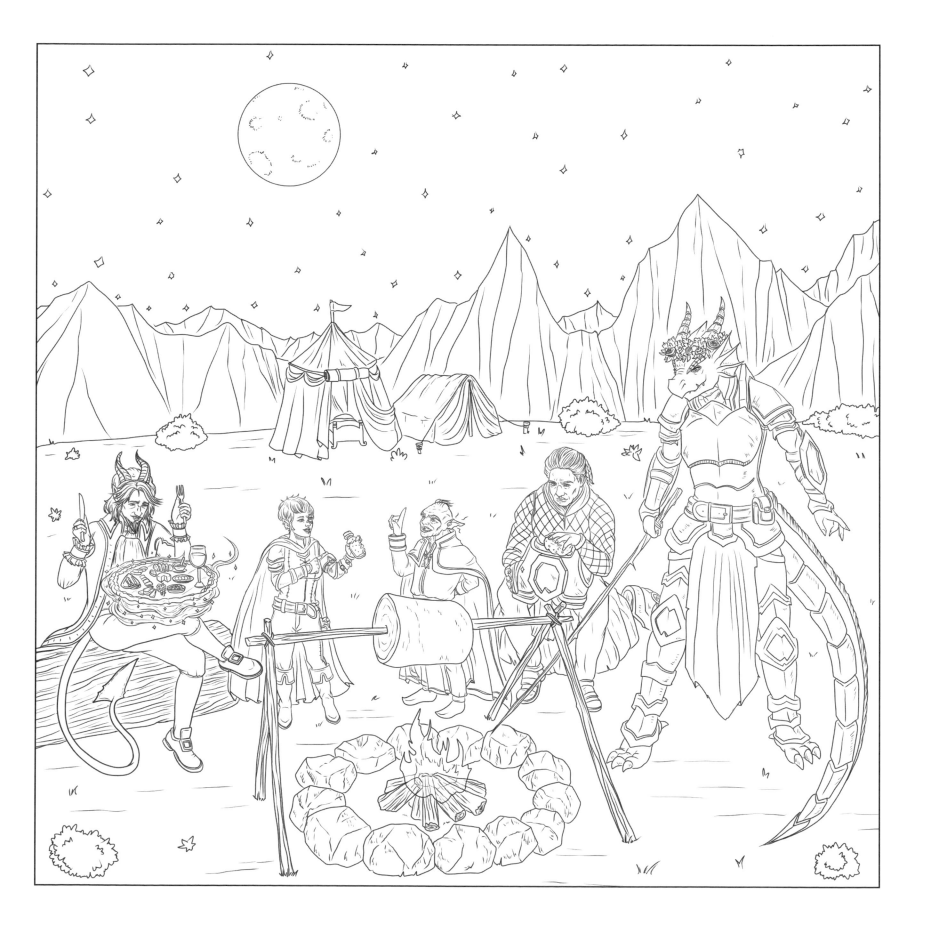

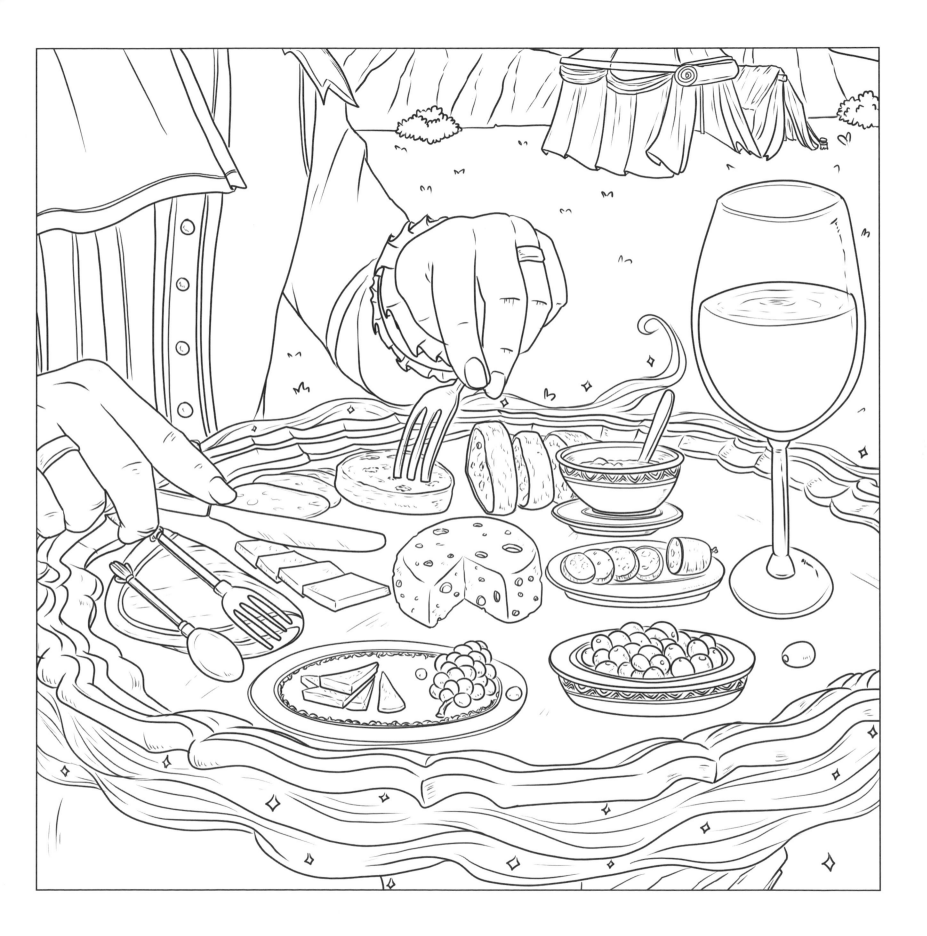

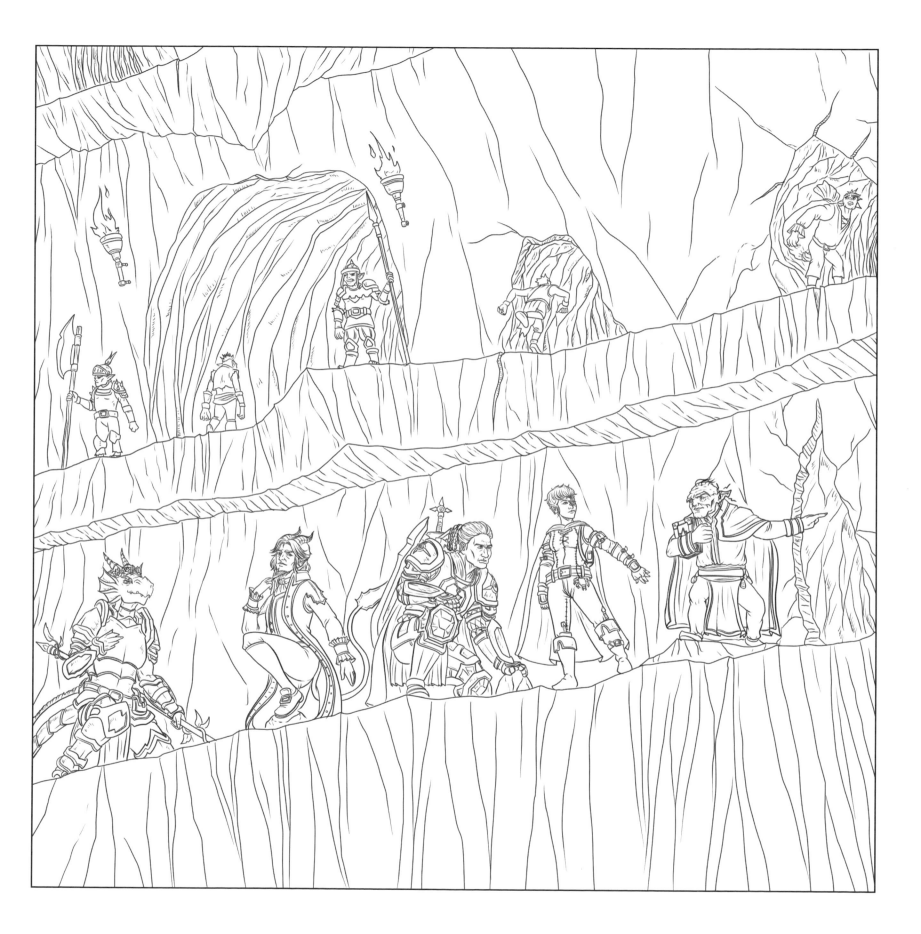

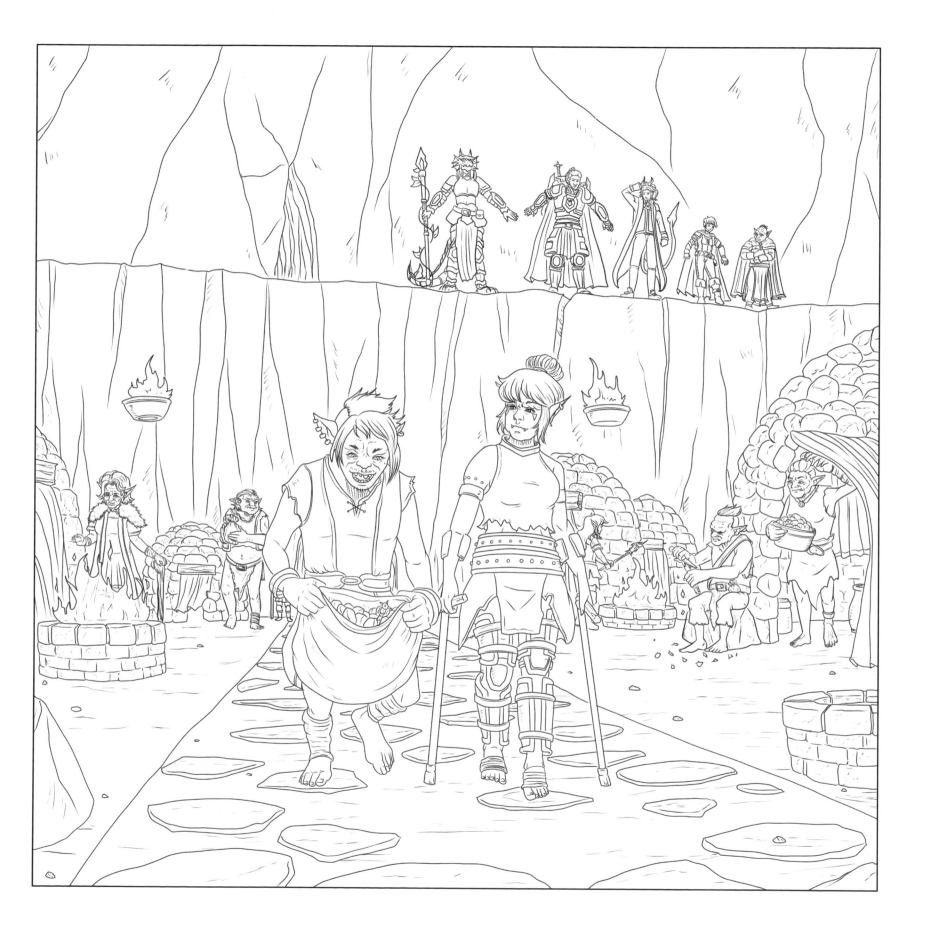

A Treacherous Climb: Surviving Stonefang Peak

Having skillfully and sneakily made it through the Rik-Tik goblin village and out the other side, the party meets the eyes of an unexpected prisoner of the aggressive goblin campaign. A weary one-armed elf is held captive in a hanging cage. Deciding to help get them down with Catalina's lock-picking skills, the party learns that their name is Serin Athellien and they are an accomplished warrior that got captured trying to protect a farmstead in the wilderness.

Serin is eager to join in the group's quest to put a stop to these raids and takes a sword and armor from a pile of abandoned gear near the cages. Together, the group continues up the treacherous mountain path and over a rope bridge that's barely holding together, overlooking a chasm. The path eventually leads to an ancient and mostly abandoned dwarven city. As the group approaches the great metal doors to the mountain city, a goblin sorcerer and lizardmen warriors surround the heroes; they must fight for their lives.

Thanks to the group's new elven addition, they barely scrape out another victory. The party wearily ventures into the dwarven city's Stonefang Lair and its great library. The library houses many valuable pieces of literature, fighting manuals, and rare weapons. The treasures of the room reenergize the heroes as their true enemy, ever watchful, lurks in the background.

Library's Exotic Weapon Proficiency

In the library, the players can find a magical manual that trains a player in the use of a randomized weapon. Roll once for each column to get the full weapon type. Once read, the book becomes a magical version of that weapon. GMs may also give one weapon randomly to every party member. When in doubt, the conjured weapon does the same damage as a longsword.

Percentile	Descriptor A	Descriptor B	Weapon C
01–04	Elvish	Double	Axe
05–08	Dwarven	Treble	Sword
09–12	Halfling	Half	Bow
13–16	Gnomish	War	Dagger
17–20	Orcish	Mercurial	Mace
21–24	Demonic	Assassination	Boot
25–28	Draconic	Throwing	Star
29–32	Robot	Dining	Chain
33–36	Goblin	Hunting	Whip
37–40	Human	Medicinal	Stone
41–44	Variant Human	Silent	Club
45–48	Bugbear	Deafening	Fan
49–52	Dark Elven	Farm	Thousand-Folded Katana
53–56	Chelonian	Chained	Clump
57–60	Kenku	Gadget	Gloves
61–64	Half-Orc	Umbrella	Contraption
65–68	The Discerning Lady's	Spring-Loaded	Bomb
69–72	The Dapper Gentleman's	Folding	Dust
73–76	Extraplanar	Monofilament	Half-Spear
77–80	Enormous	Telescopic	Grenade
81–84	Lycanthropic	Transforming	Statue
85–88	Insectoid	Plasma	Polearm
89–92	Forgotten	Inflatable	Hammer
93–96	Roll again, add "Dire-" prefix	Instant	Arquebus
97–00	Roll again, add "Ancient-" prefix	Roll twice, take both results	Roll twice, take both results (dual weapon)

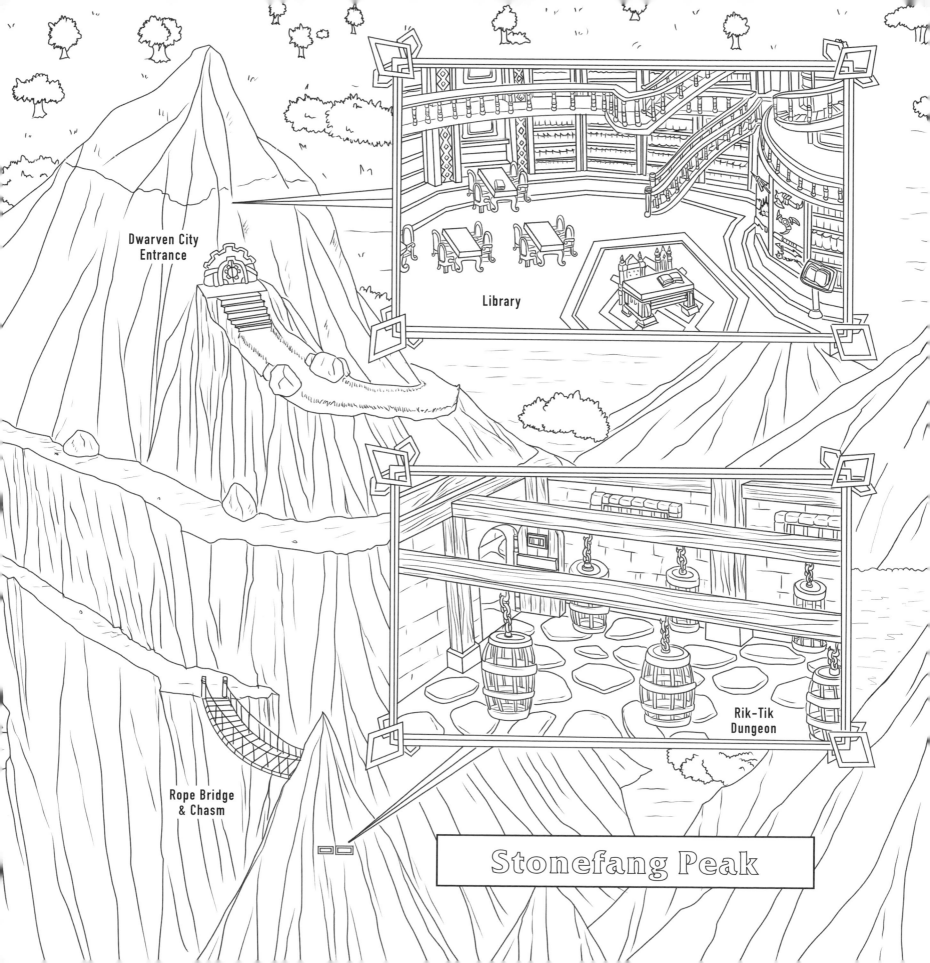

Dwarven City Entrance

Library

Rik-Tik Dungeon

Rope Bridge & Chasm

Stonefang Peak

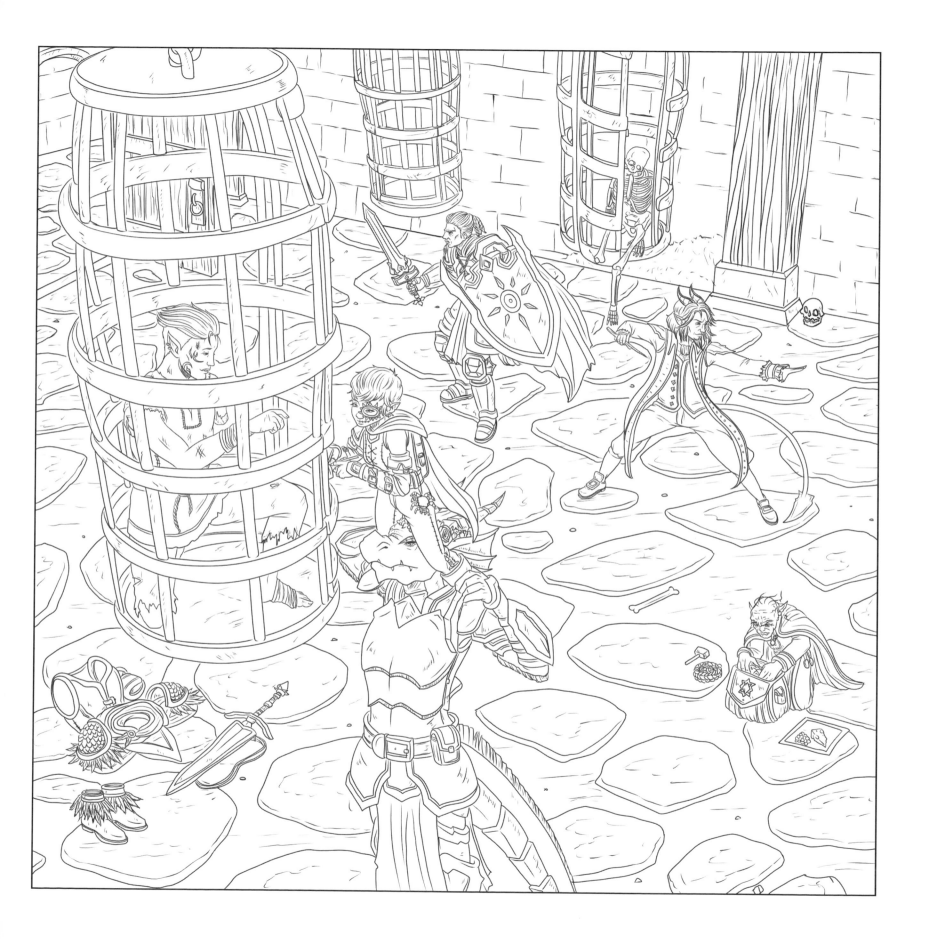

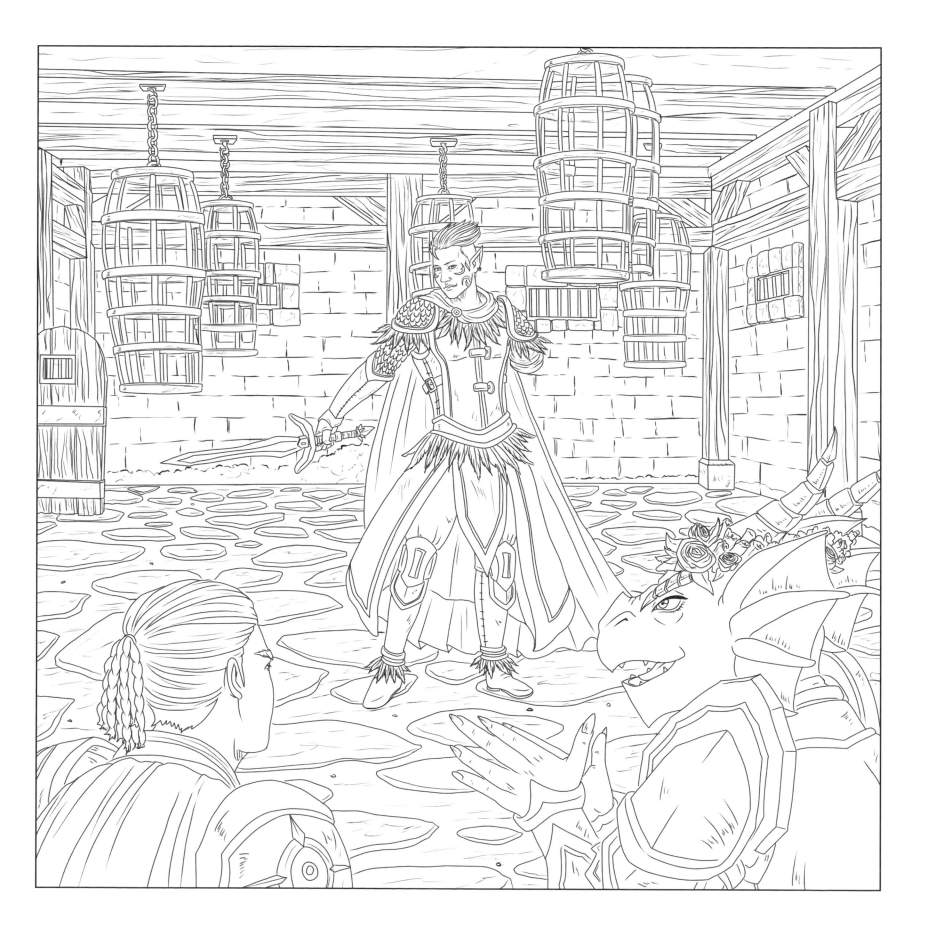

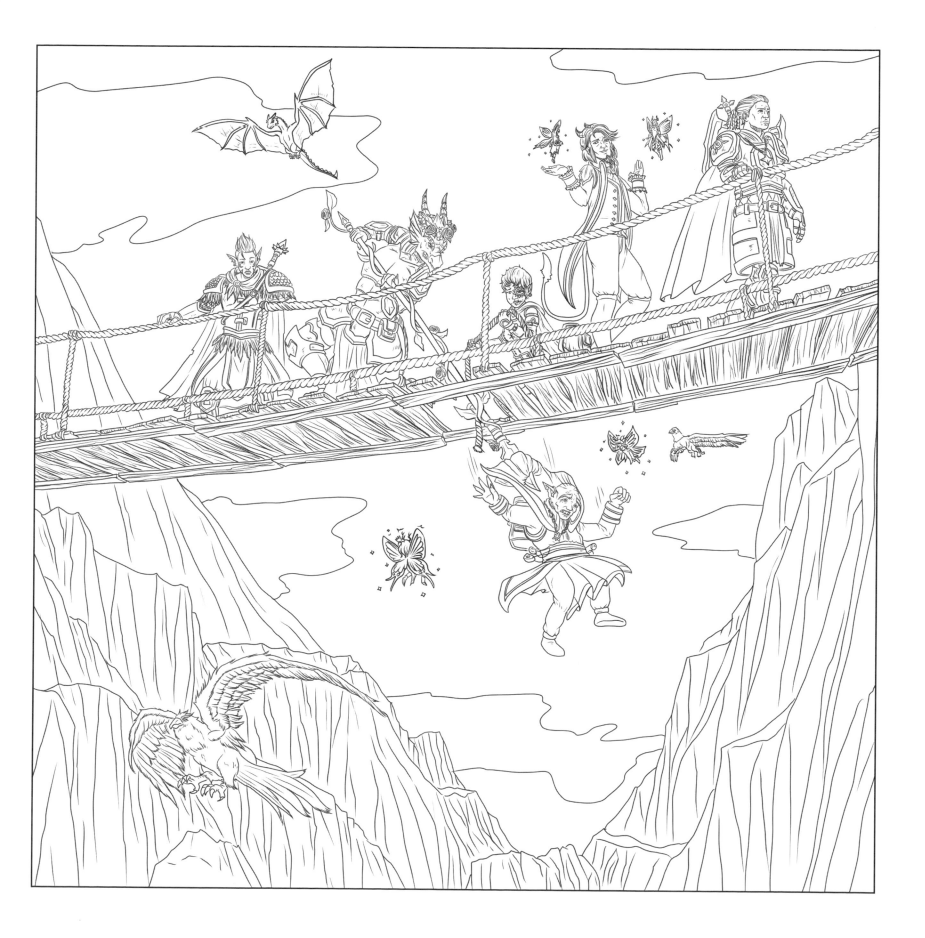

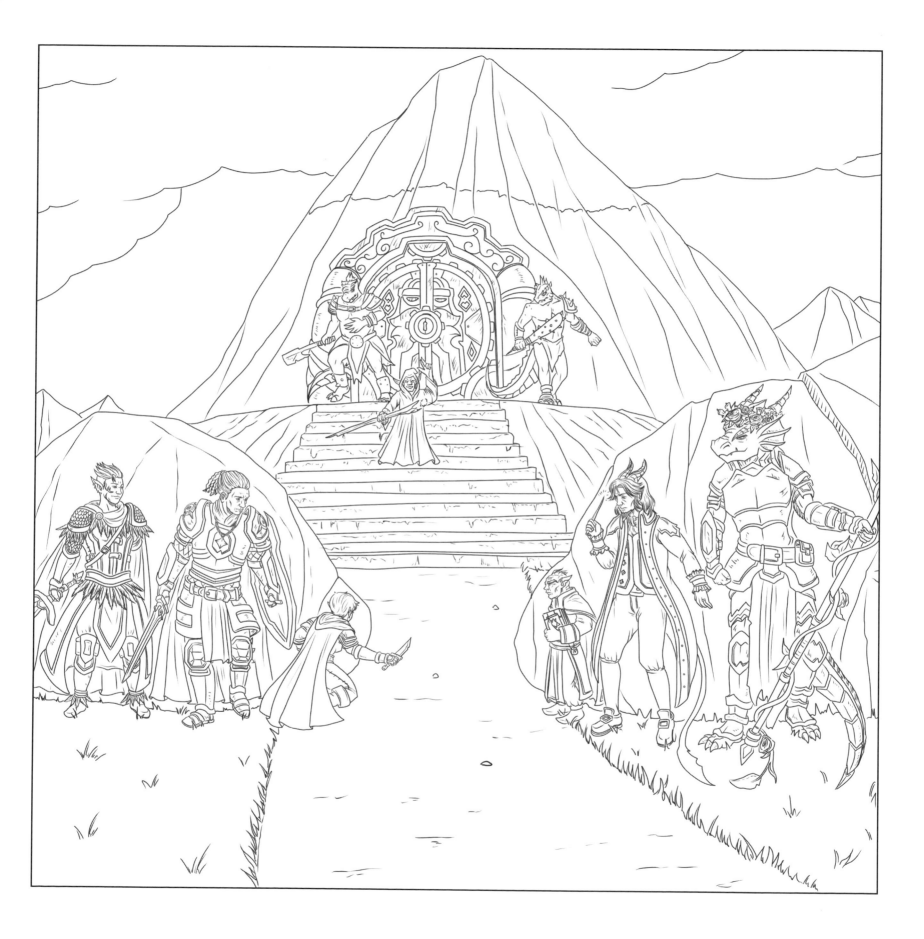

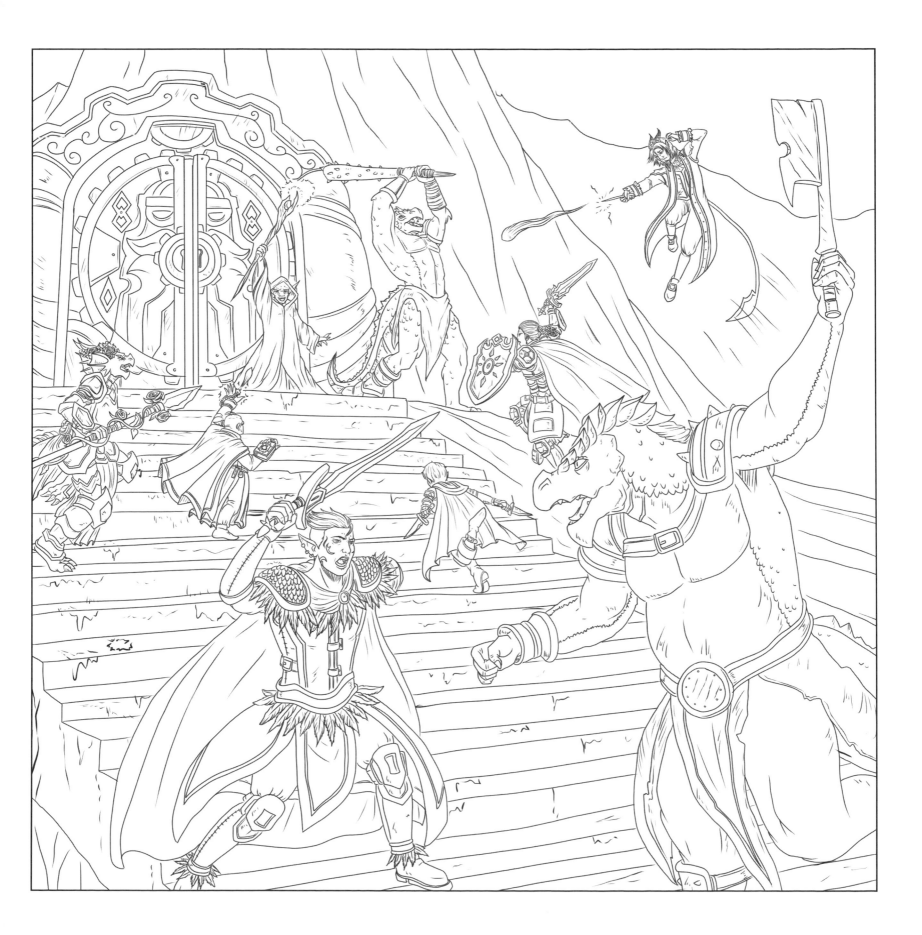

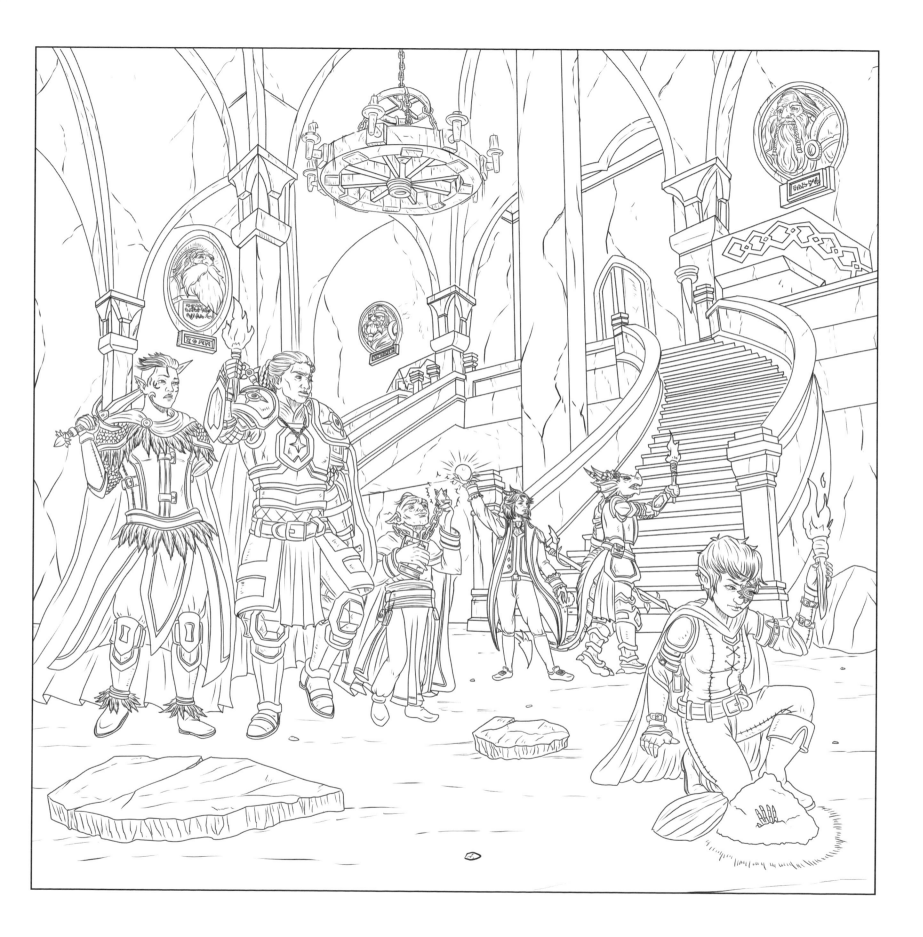

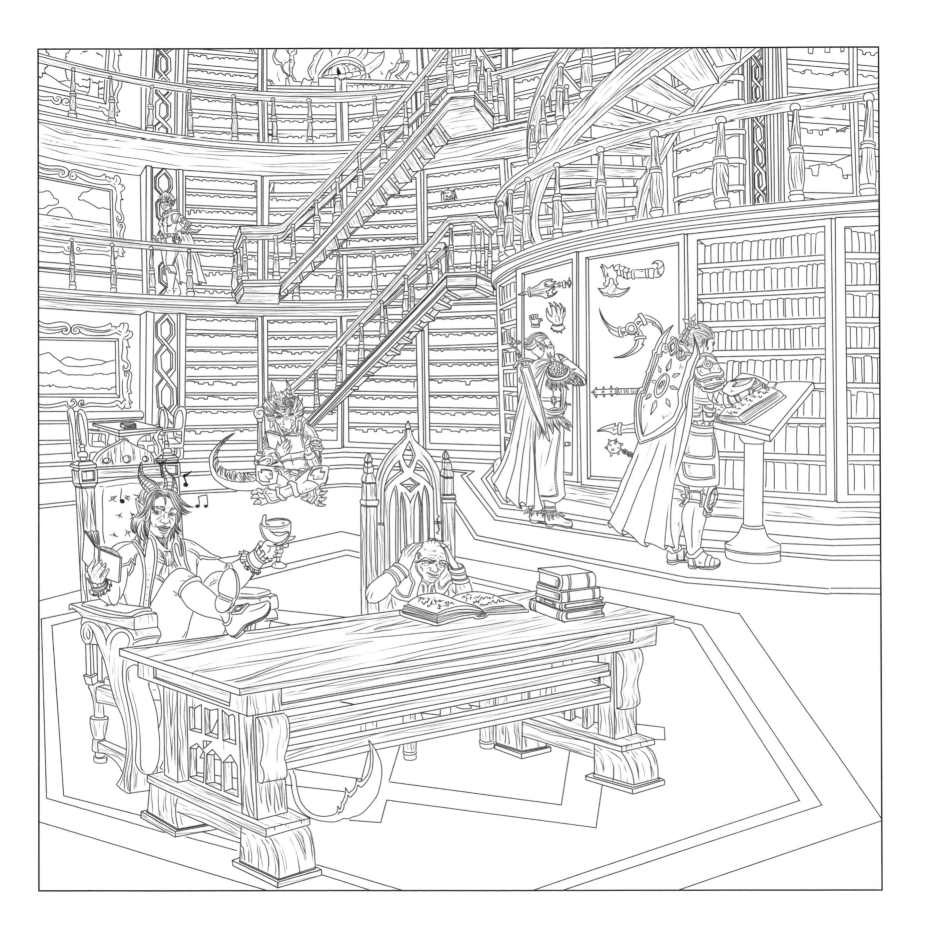

The Final Boss: The Dragon Attacks!

Having made it through the goblin warrens and Rik-Tik Village, our heroes make their way into Stonefang Lair, home to their true foe. Leaving the great library, they wander into the Aerie Hollow Cave and come face-to-face with the dreaded dragon of Wyvernspine Pass!

A fierce battle rages between the group and the wyrm, forcing the heroes to split into pairs for combat. Though it looks as though they will not pull through, Serin's decisive blow to the dragon's neck awards the group a victory. Unfortunately, they have only seconds to bask in the spoils of their newfound hoard before an unexpected trap, triggered by Jack snatching a shiny scepter, begins to flood the chamber with a rush of icy elemental water.

The current sends the heroes on a careening journey down the rapids and falls of the Ainok River, battling elementals and monster piranha all the while, until they blessedly reach safety a few miles north of Tidehallow.

They venture back to town and are celebrated by the people of Tidehallow. Finally, having restored peace between the goblins and the townsfolk for now, our noble (well, most of them) heroes look to depart from the seaside town. Grobtic and Serin formally join the Greenscale Company, and they all board a sailing vessel bound for unknown seas and adventures in the world beyond!

Dragon Color

The abilities and attitude of the final dragon boss will be decided entirely by a roll of your dice. Or color your dragon whatever color you'd like and refer back to the table for a surprise special ability and breath weapon. In addition to the standard dragon colors, there are a few surprising new colors for kicks!

Roll	Color	Special Ability	Breath Weapon
1	**White:** White Dragon	**Blizzard Aura:** Slows and deals 2 damage per turn in 10' radius.	**Ice Shard Barrage:** Deals 2d10 cold damage and renders the target's space and the spaces within 5' of them as difficult terrain.
2	**Blue:** Blue Dragon	**Amphibious:** Has Water speed 6; can dive for cover and hide in the wellspring.	**Lightning Breath:** Deals 2d10 electricity damage in a 40' line and inflicts Paralysis (save ends).
3	**Green:** Green Dragon	**Emerald Hide:** Reduces damage of ranged attacks and spells by 2.	**Poison Breath:** Inflicts 2d6 damage to all targets in a 15' area and poisons the target. They take 1d6 additional damage per round (save ends).
4	**Red:** Red Dragon	**Blazing Constitution:** Advantage on saves against Poison and effects that deal damage.	**Fire Breath:** Inflicts 3d10 damage in a 40' cone.
5	**Black:** Black Dragon	**Gasbag:** When the Black Dragon reaches half health, it immediately uses its breath weapon in cones in front of and behind it.	**Gas Breath:** Deals 2d10 damage in a 30' cone and inflicts Blind (save ends).
6	**Yellow:** Banana Dragon	**Appealing Skin:** Gains +4 AC until below half health.	**Potassium-Rich Breath:** Deals 2d10 damage in a 10' square at 30' range; 10' area will explode again at the start of the dragon's next turn, inflicting 1d10 additional damage.
7	**Purple:** Dragon Prince	**Purple Drain:** When damaged with a spell, the caster also expends one spell slot of a lower level.	**Raspberry Breath:** Deals 2d10 damage in a 40' line, and grants combat advantage to the dragon against any attack until its next round ends.
8	**Orange:** Hazard Dragon	**Warning Signs:** Creates 10' aura of difficult terrain.	**Hazard Breath:** Deals 2d10 damage in a 30' cone and leaves the area difficult terrain for 1d6 rounds.
9	**Miscellaneous:** Scintillating Dragon	**Rainbow Road:** Whenever completing an attack round, the Scintillating Dragon can move up to 10'.	**Bubble Breath:** Hits a single target within 30'. In 1d3 turns, the target explodes bubbles outward, taking and inflicting 2d10 damage to targets in 10'.
10	**Clear:** Glass Dragon	**Hard to Spot:** Attacks made from more than 20' away have disadvantage.	**Shard Breath:** Deals 3d10 damage in a 30' line and inflicts Stun until end of turn.

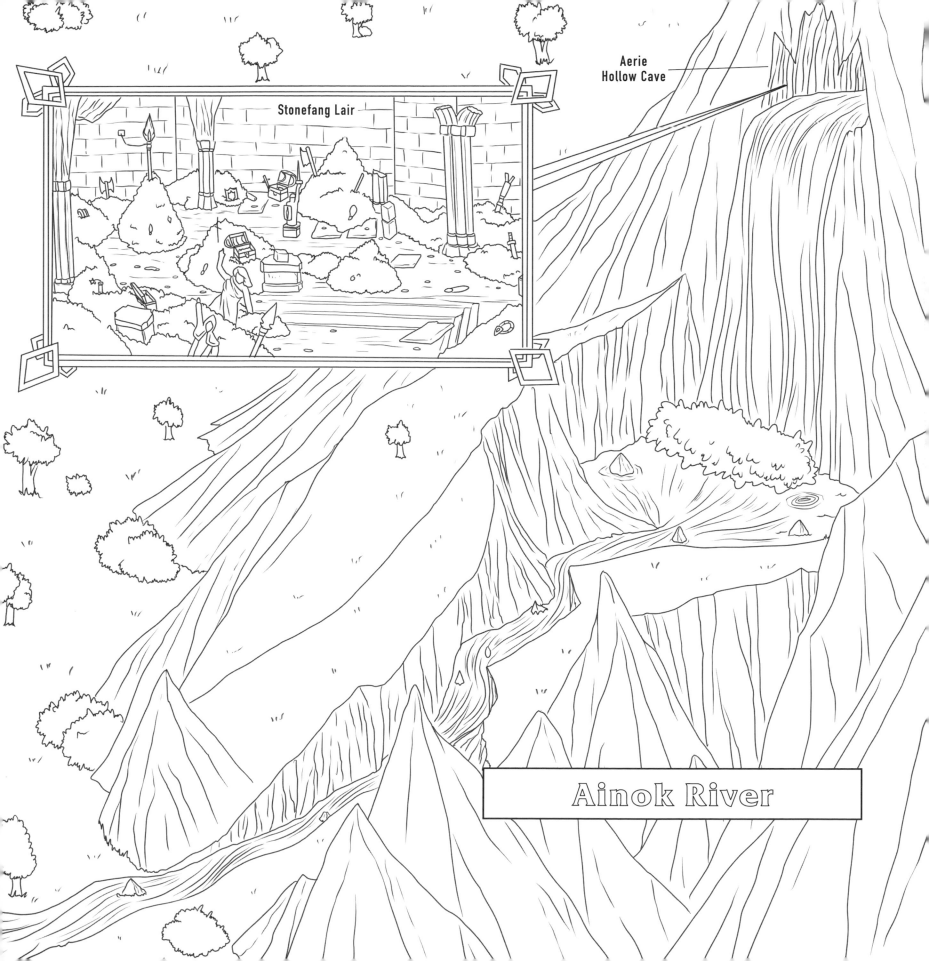

Aerie
Hollow Cave

Stonefang Lair

Ainok River

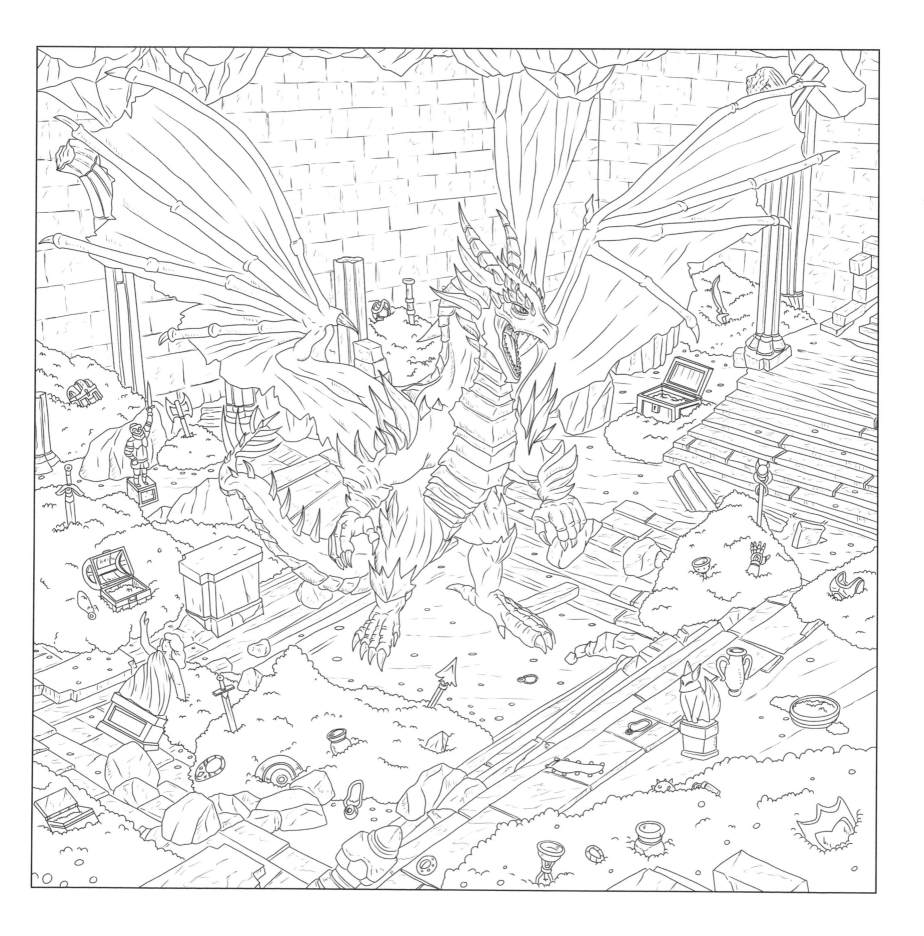

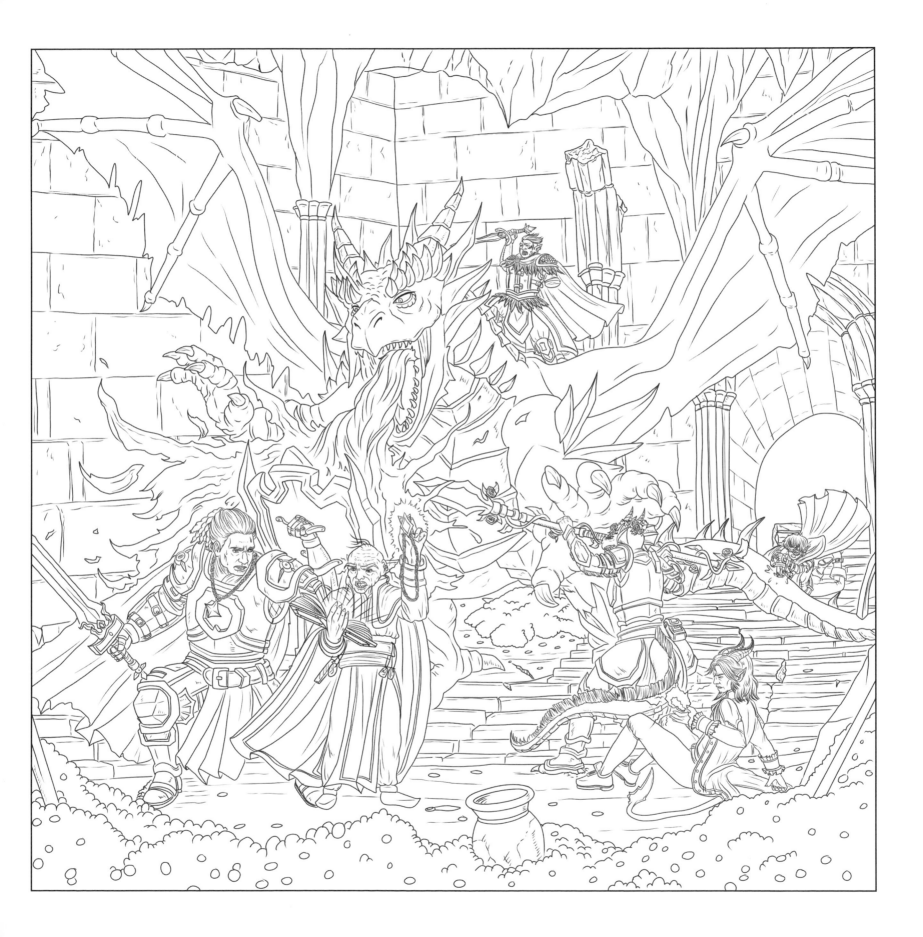

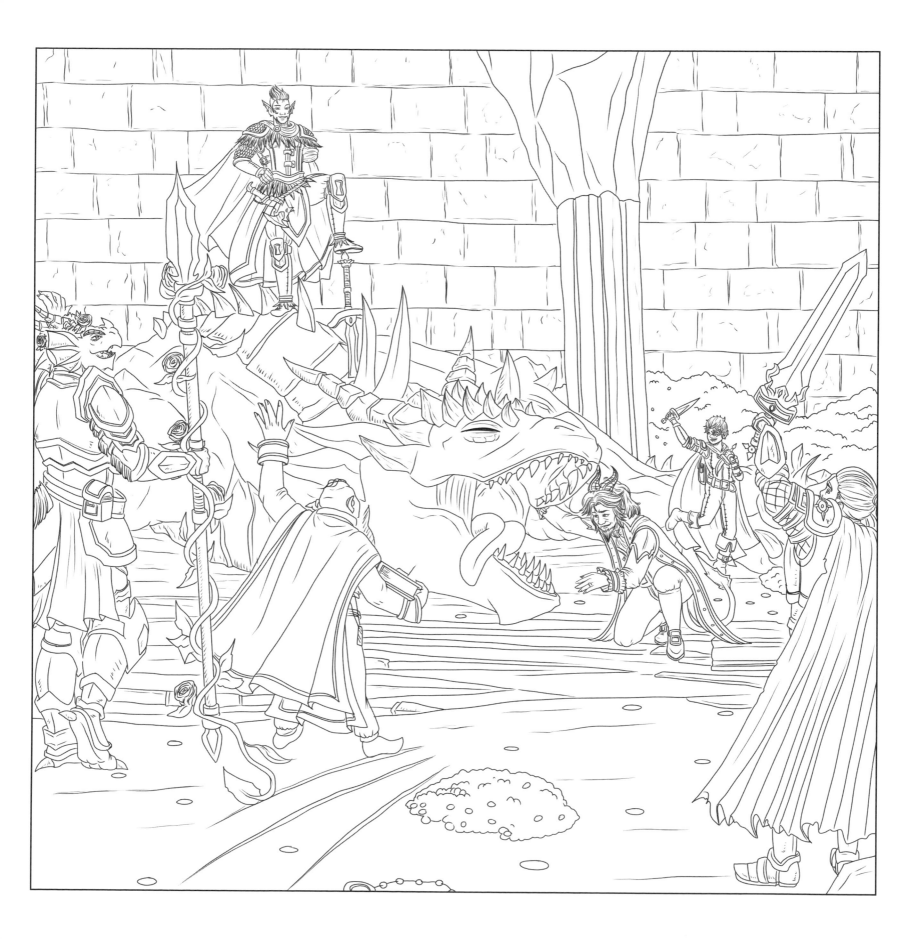

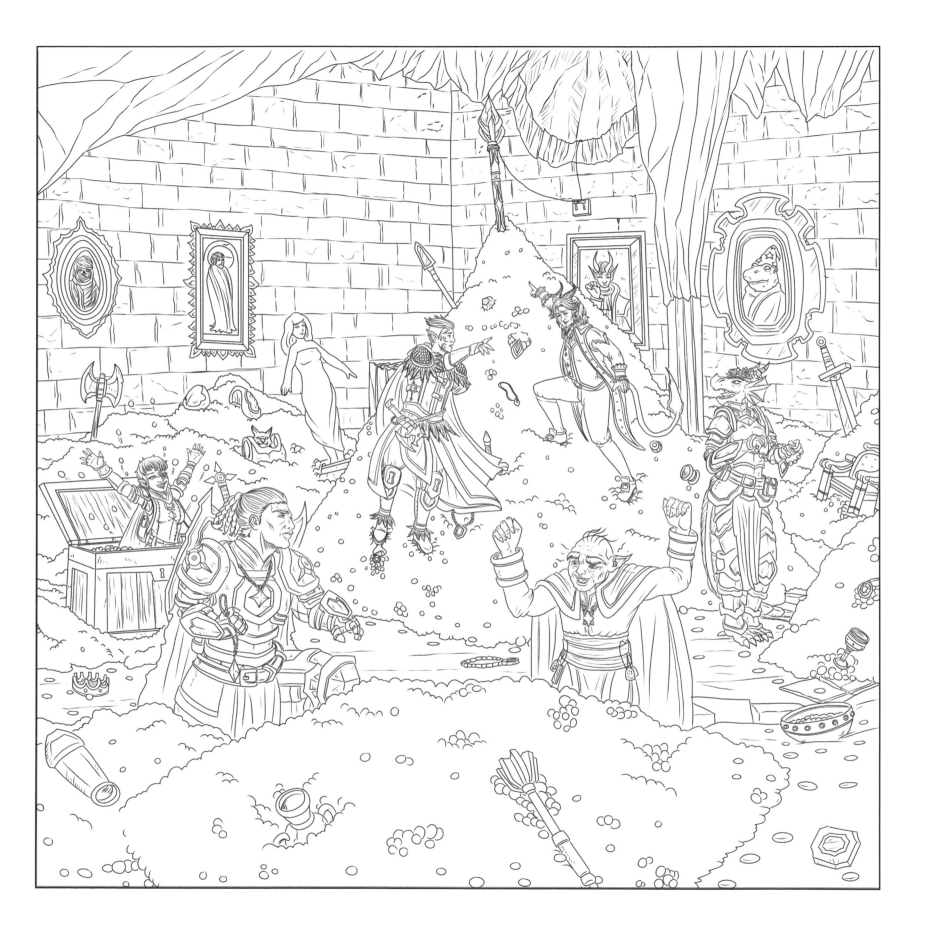

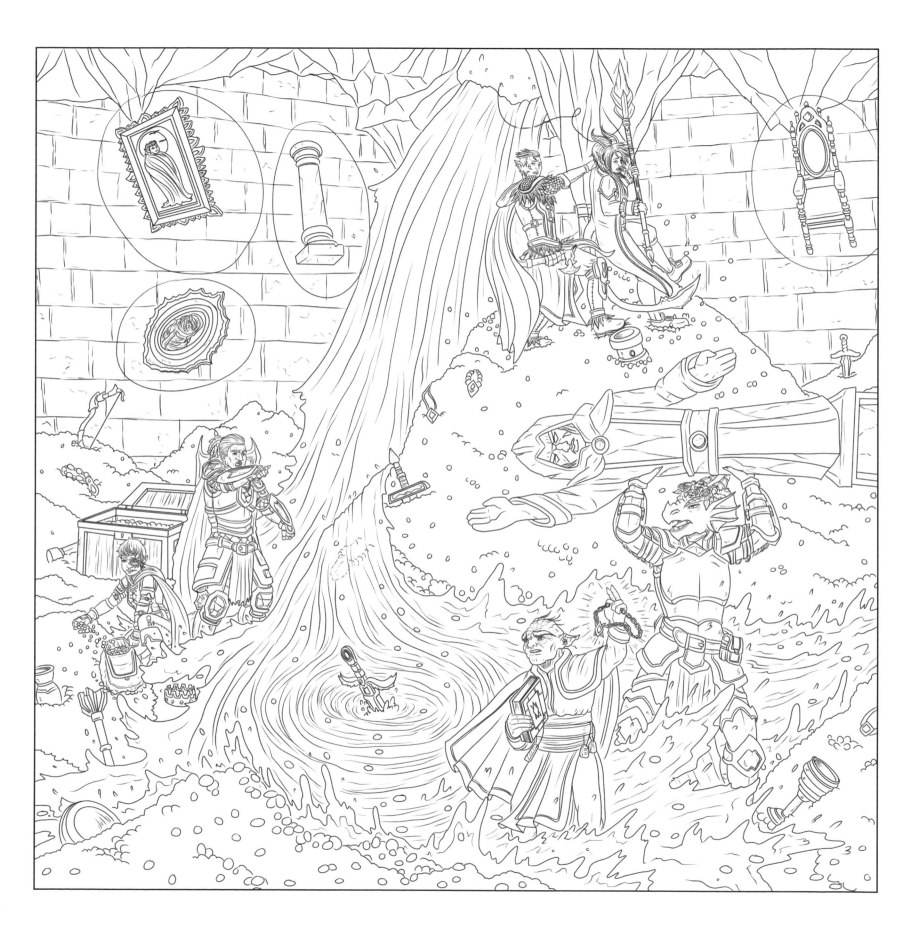

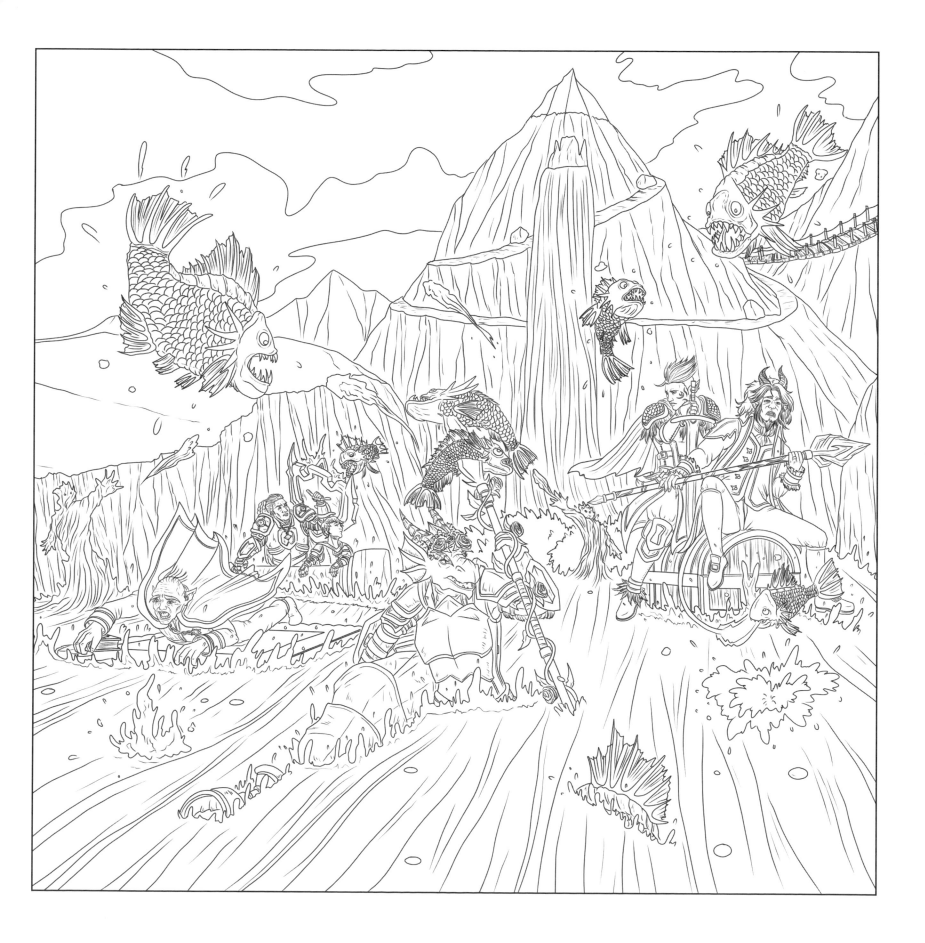

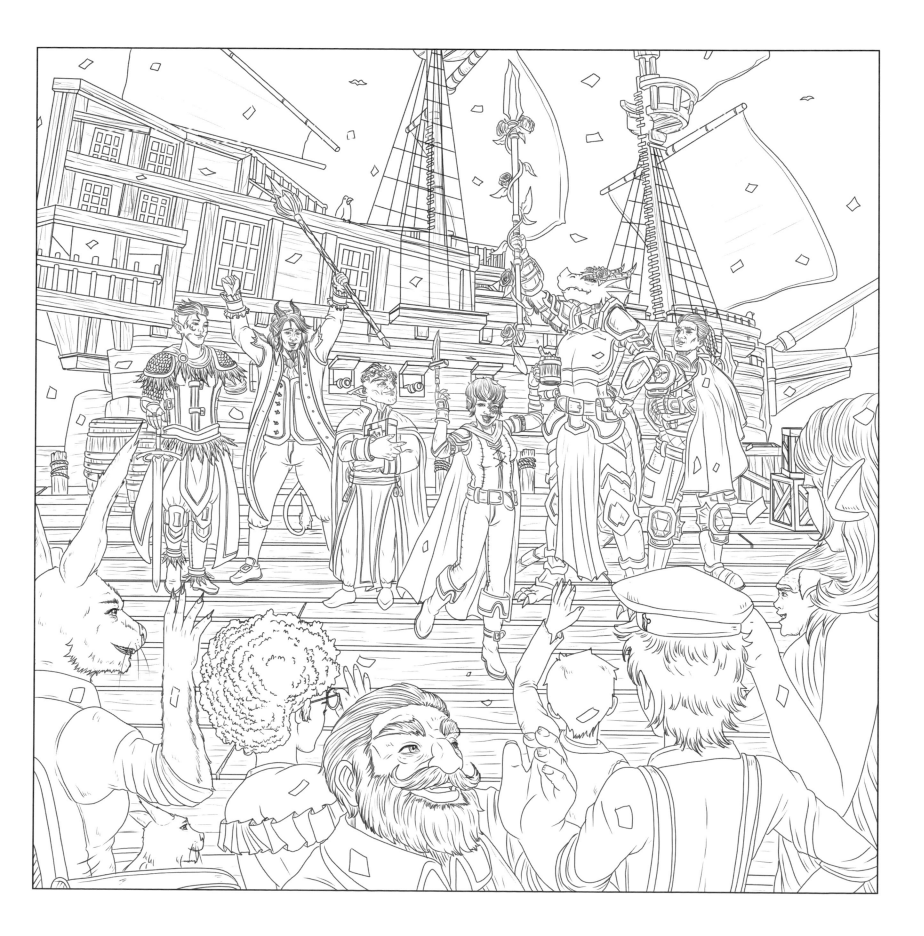